I go to bed and sta...
mixing colours: re...
blues with greens ...

Shirley Trevena

Shirley Trevena is a well-known watercolourist with an international reputation who is regarded as one of Britain's most innovative artists in the medium. She is a Member of the Royal Institute of Painters in Watercolours and President of the Sussex Watercolour Society. She is the author of three best-selling books, *Taking Risks with Watercolour*, *Vibrant Watercolours* and *Breaking the Rules of Watercolour* and three DVDs. In 2010 she was the British representative at the 7ème Festival International de l'aquarelle in Antwerp and in 2011 exhibited at the Biennale de l'aquarelle, St Cyr sur Mer, France. In 2014 she was a finalist in the World Watercolour Exhibition in Narbonne, France.

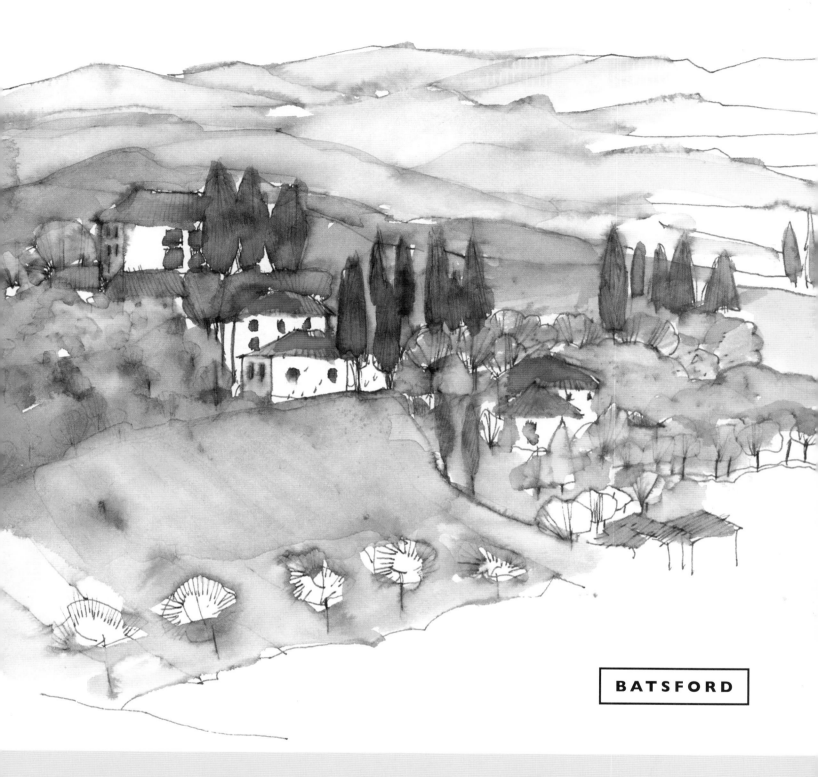

BATSFORD

Shirley Trevena Watercolours

Introduction

This is predominantly a picture book with very few words, everything chosen to give the reader a closer, more personal view and hopefully a valuable insight into my evolving work as a watercolour artist.

For over 30 years I have produced many paintings, some good, some okay and some easily forgotten. I have even experienced walking into a friend's house and admiring a painting on their wall, only to be told that it was one of mine painted some 25 years ago. On closer inspection it then proved difficult for me to imagine how I had dared to put paint down in that way, but I could see bits of future Trevena's in it and even vaguely remember the composition.

On thinking about this surprising incident, I thought how useful it would be to look again at work I had agonised over many years ago. I am a great believer in the need to keep past efforts: bits of drawings; experimental work and neglected paintings only half finished which will never be framed but may be useful one day; hundreds of scraps of paper, photos and bits of magazines all cut out and put away either with the hope that I would be inspired at some future date by their subject matter or, as in some cases, thumbnail sketches that had been turned into successful paintings.

All these images whisk me back 30 years or more. It felt as if I was studying a family photograph album where you can see on one page your aunts and uncles when young, pulling silly faces and doing cartwheels, and then you turn the page and see them as they are now, older and rather more defined.

I like this idea of seeing time pass with images and decided to try to reproduce it in book form. But I also wanted to have time to go backwards as well as forwards and that meant putting new paintings, straight from the studio, next to earlier work using similar ideas and objects, but probably painted more than 20 years before. I would write my thoughts, ideas and the stories behind many of these pictures, giving the reader an insight into my work as it has evolved.

As a teenager I was destined to work in an office – unfortunately art college was not an option. In my hunt for images in this book I did manage to find a few drawings made when I was a child, and looking at them now, I can persuade myself that I can see the beginnings of my need to break the rules of perspective – although young children don't bother with that rule – that's what makes their pictures so exciting.

I found some fairly competent, tight pencil drawings. I was obviously looking hard at my subject matter and knew how to wield a pencil but not a lot of risks were taken then. There are a few paintings of the type I started with when I gave up my office career. They are quite bold and expressive. I knew nothing about using watercolour and so it was all trial and error. I found out in later years that this was a big advantage. My excitement and need to experiment carried me through to discover the beginnings of a style of painting that would be recognizable – mine.

In parts of the book I have included paintings that in my opinion are the best I have ever produced, the ones that I wish I had never given away or sold. Looking again at these favourite paintings helps me to judge if the work I am involved in now has moved on in any way, or if I think I still haven't bettered these earlier pieces.

You will see quite a few paintings that shine a light on my interests, such as my love for the cinema, theatre and, a real favourite, the circus life. My childhood was packed with visits to these spectacular events. I was told that my first visit to the theatre was as a baby on my mother's lap while my father was at the back of the theatre working the spotlights onto the stage. My mother was also very theatrical in her early career and later life but she would have been horrified if I had run away to join the circus, which seemed such a magical idea at the age of 10.

After the early portraits, I became known for my still-life paintings. I had a strong desire to work with familiar, recognizable items and to try to change their ordinariness to make them special in some way. My studio is full of these wonderful objects, jugs, vases, metal animals and fabrics – all of which appear time and time again in my paintings. I still have a need to see what happens when I put, perhaps, a pink tin jug next to an orange cup. I have even managed to find a picture of a tea set that I drew when I was about 9 years old. I was obviously going to become either an artist or a teashop owner when I grew up.

Holiday time always gets me drawing, and I have included some of these sketches. Although not a landscape artist, my eyes are always taking in angles of trees and rooftops, walls and fences. Strong, straight lines against organic curves is a theme that runs through most of my work, and flowers are also a great source for this. Lilies with spiked leaves, tulips, of course, and amaryllis with large fleshy flowers balanced on stalks like celery sticks. Most of my still-life paintings begin with a flower or two and you will see quite a few amaryllis in the book in various poses; it's the flower I can't resist buying and always end up painting.

I have selected some pictures of what I call my 'breakaway' work, where I have used different media and stepped away from watercolour for a while. I had a chance to work with a friend who taught me monoprinting and for several months I was completely absorbed by this medium. Then, little by little, a bit of collage crept in, and then some watercolour paint and the pictures became mixed media. I then returned to watercolour and my usual subject matter. I had enjoyed producing monoprint landscapes, but it was still life that took me back to painting.

Another breakaway project was some abstract painting completed when I was living in France. There again it surprised me that I went for landscapes but it seemed so right when I was living in the middle of nowhere surrounded by trees and fields.

Amongst these breakaway pictures are some of my recent paintings in which I have tried to move away from my concept of bringing several objects together and binding them into a tight composition. I am now attempting to put more air into the pictorial space, separate the objects and form larger, quieter moments that are part paint, part graphite pencil and white paper.

Anyone who aspires to writing a book is usually told to stick to what they know, be it in their past or their day-to-day living. In putting this book together I have definitely taken that advice to heart but I also asked myself what sort of book would interest me. I would want a 'luscious, can't wait to see what's on the next page' book. I remember feeling like this when I looked through a book about David Hockney's early drawings and one about Matisse's wonderful cut-outs, produced right up to his death in 1954. All these images were so inspiring and gave me a feeling of closeness to the artist as they began or ended their search for that perfect piece of work.

I hope you enjoy my scrapbook of images. Putting it all together was quite an emotional roller coaster for me, reliving my youth, my impressions and memories of past and present work.

S. Fisher

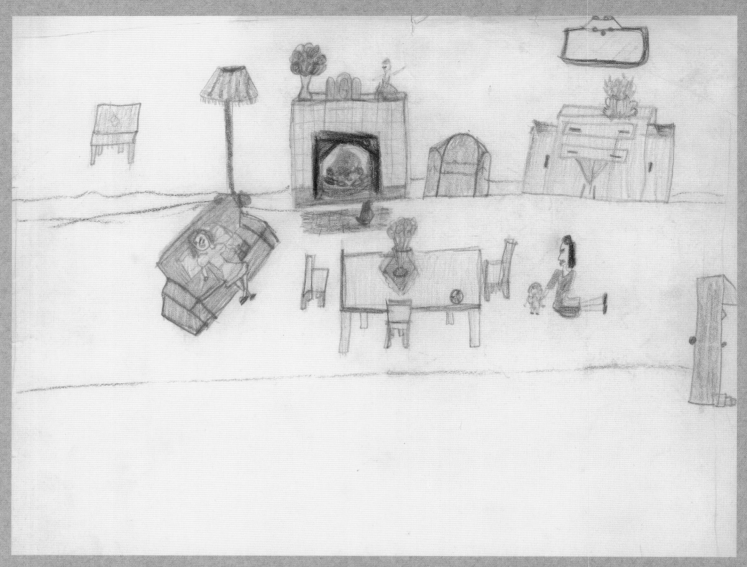

In The Living Room (aged 7 or 8)
Crayon
18 x 20cm (7 x 8in)

These pages show two of my pictures drawn when I was about seven or eight years old. My mother kept the little book that I had filled with sketches of our home, including the kitchen, bedroom and this one of the dining room. I love the details of ornaments on the mantelpiece, the flattened table and the sideways view of the front door.

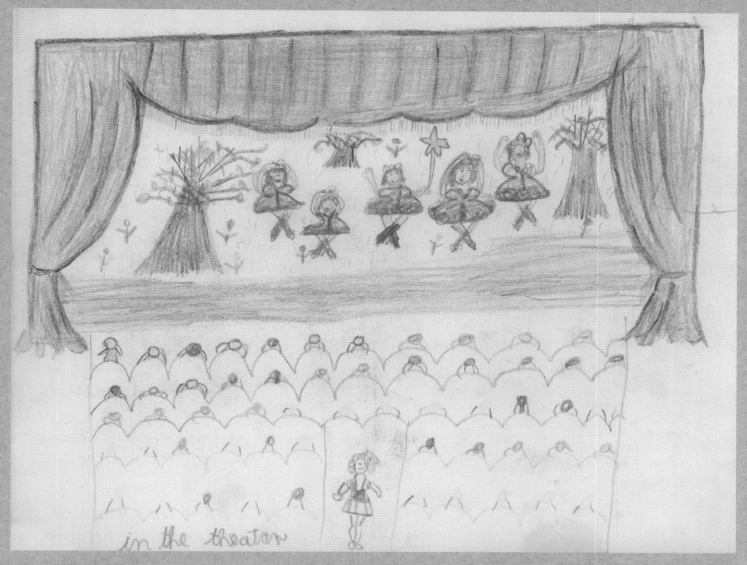

In The Theatre (aged 7 or 8)
Crayon
16 x 20cm (6¼ x 8in)

As a baby, I was often taken to the theatre, and this sketch looks like
a scene from a pantomime. Pantomimes were a yearly treat. I must have
been seven or eight years old when I drew this but it looks as if my
mother added the skilful drawing of the curtains — I wasn't that good.

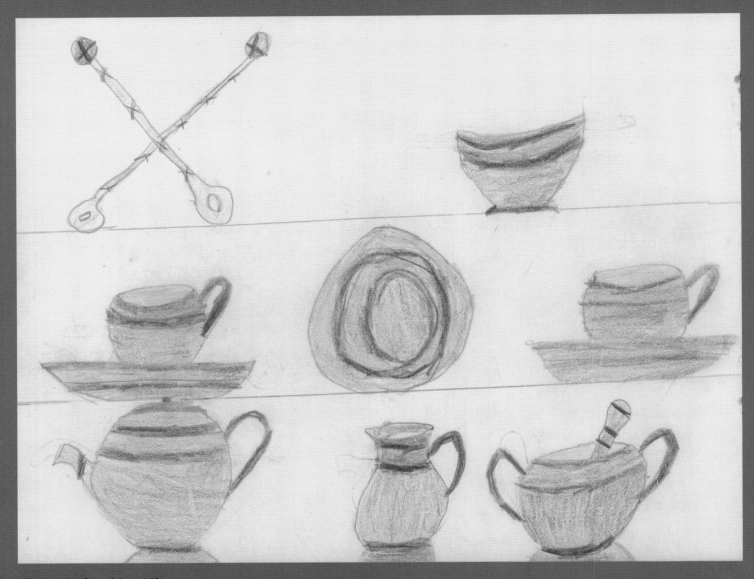

The Tea Set **(aged 9 or 10)**
Pencil and coloured crayon
18 x 22cm (7 x 8¾in)

This pencil and crayon drawing was put together when I was probably nine or ten years old. I was obviously obsessed by cups and jugs even then. Details of a few future paintings, shown opposite, clearly show my continuing love of tea time.

Still Life with Grapes and Oranges, **detail (1994)**
Watercolour
56 x 46cm (22 x 18in)

Green Glass Vase and Pink Chair, **detail (2003)**
Watercolour
47 x 51cm (18½ x 20in)

Teacup and Teacloth, **detail (1993)**
Watercolour
35 x 40cm (13¾ x 15¾in)

Pencil drawing **(1969)**
Pencil
24 x 24cm (9½ x 9½in)

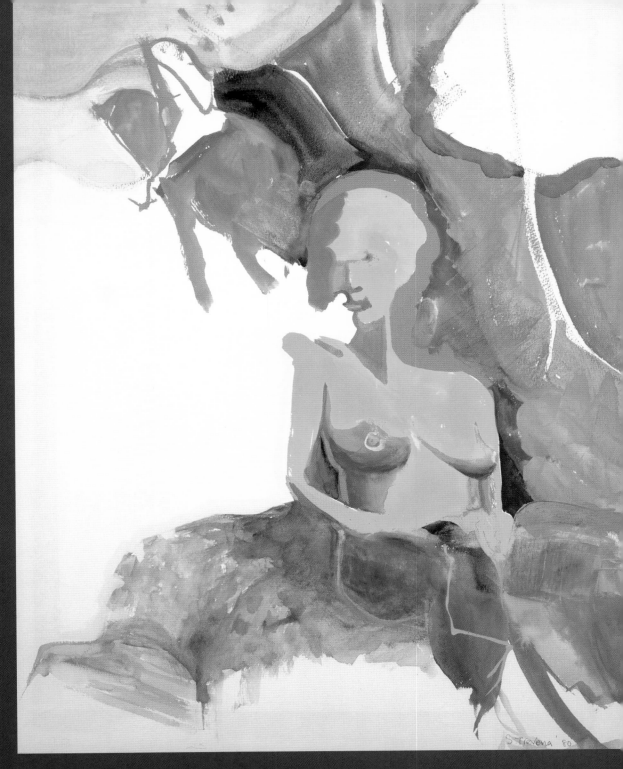

Anna's Dream **(1980)**
Watercolour
40 x 35cm (15¾ x 13¾in)

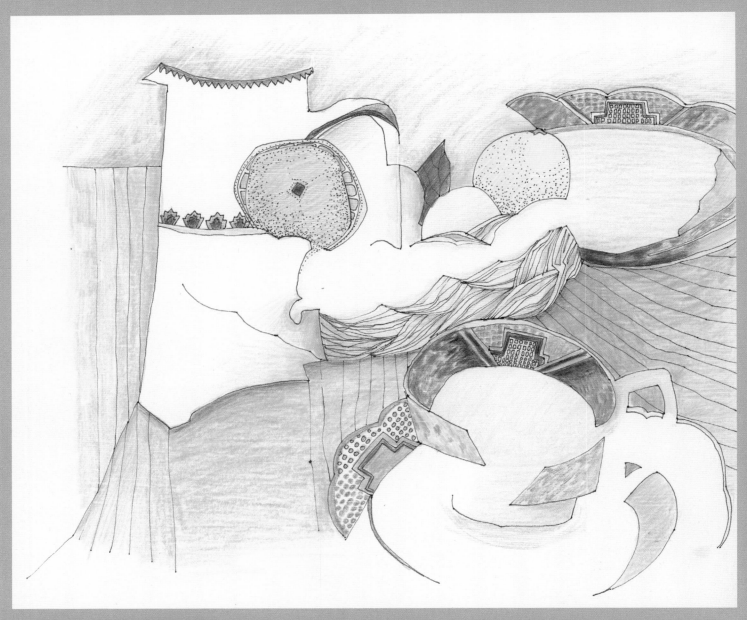

Sketch for *Blue China Still Life* (1983)
Pen, ink and crayon
21 x 26cm (8¼ x 10¼in)

Paul Klee called it 'taking a line for a walk' and for me it is like that, letting my pen or pencil wander over the page. These drawings were made several years apart, using ink, pencil and iPad.

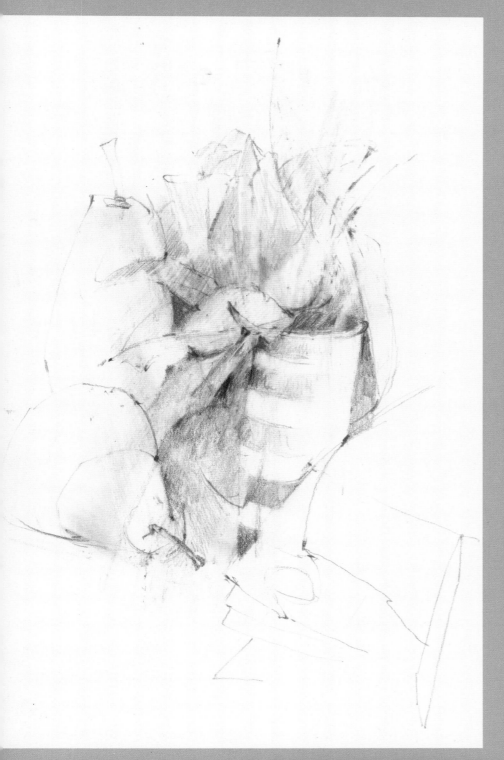

The Problem of Sleep I (2012)
iPad
20 x 15cm (8 x 6in)

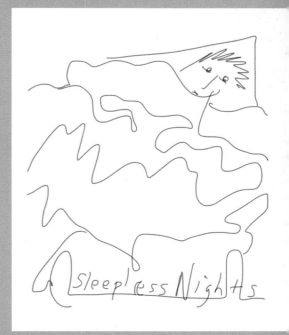

Sketch for *Small Pot and Pear* (2008)
Pencil and candle wax
20 x 13cm (8 x 5in)

The Problem of Sleep II (2012)
iPad
20 x 15cm (8 x 6in)

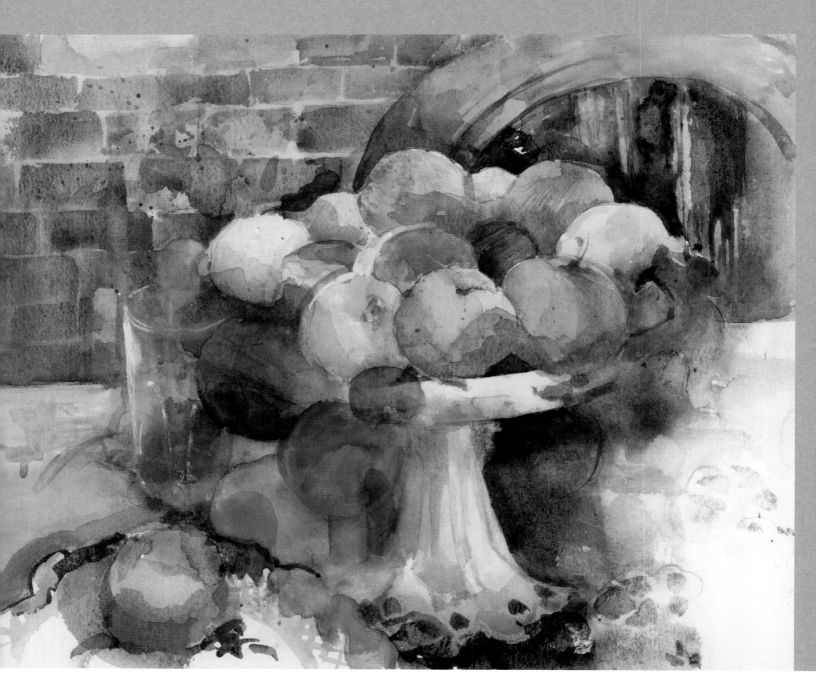

Apples (1985)
Watercolour
24 x 21cm (9½ x 8¼in)

This is the first painting in which I dared to put apples spilling over the edge of the fruit bowl. I was so excited after doing this painting that I couldn't sleep for nights, I knew I had taken a step forward.

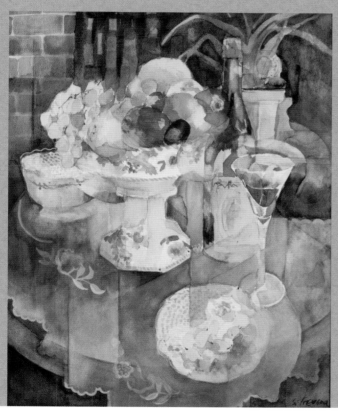

Fruit Bowl (1987)
Watercolour
48 x 38cm (19 x 15in)

Painted two years after *Apples*, only now I have tightened up the composition with vertical lines.

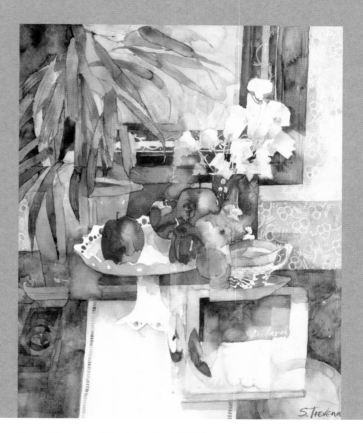

Sweet Peas and Red Apples (1993)
Watercolour
48 x 38cm (19 x 15in)

This painting is a combination of the styles of *Apples* and *Fruit Bowl*. By 1993 I had learnt to put quieter spaces into my compositions.

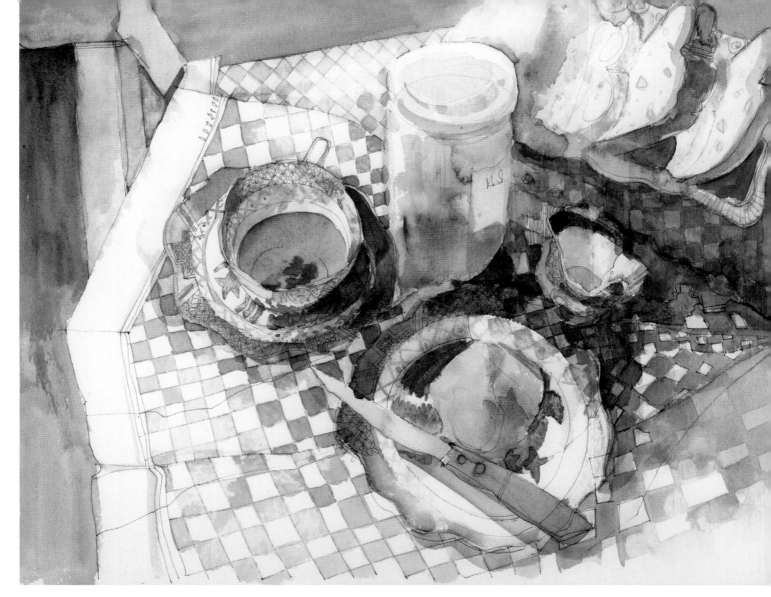

Breakfast **(1985)**
Watercolour, pen and ink
26 x 32cm (10¼ x 12½in)

Painting my breakfast

Kitchen Table took a week to paint. By the end of that the prawns smelt so bad my cats nearly tore down the studio door to get them.

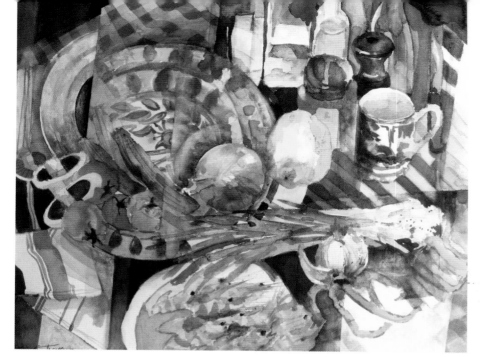

Kitchen Table (1989)
Watercolour
27 x 34cm (10½ x 13½in)

The deep red pepper and the little blue tag on the carrots inspired me to paint this still life with fruit and vegetables.

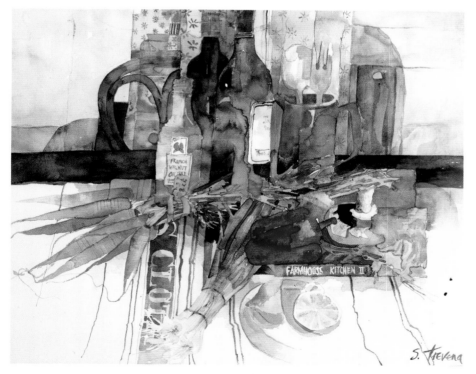

Still Life with Fruit and Vegetables (1993)
Watercolour
38 x 47cm (15 x 18½in)

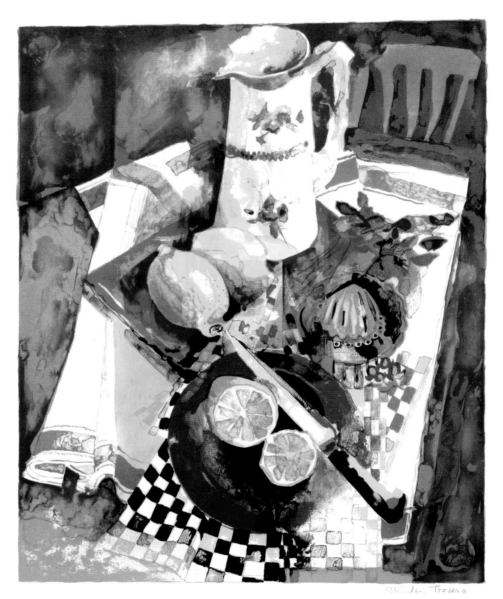

Cut Lemon **(1988)**
Lithograph
50 x 41cm (19¾ x 16in)

Shirley Trevena Watercolours

My thanks to my commissioning editor Cathy Gosling for all her support and encouragement. This, and my previous three books, would not have been possible without her.

First published in the United Kingdom in 2015 by
Batsford
1 Gower Street
London WC1E 6HD

An imprint of Pavilion Books Company Ltd

ISBN: 9781849942669

A CIP catalogue record for this book is available from the British Library.

20 19 18 17 16 15
10 9 8 7 6 5 4 3 2 1

Reproduction by Tag Publishing, UK
Printed by Toppan Leefung, China

This book can be ordered direct from the publisher at the website: www.pavilionbooks.com, or try your local bookshop.

Lithography

lith | og | raphy

Noun

The process of printing from a flat surface treated so as to repel the ink except where it is required for printing.

In the lithographic process, ink is applied to a grease-treated image on the flat printing surface; non-image (blank) areas, which hold moisture, repel the lithographic ink. This inked surface is then printed directly on paper, by means of a special press (as in most fine-art printmaking).

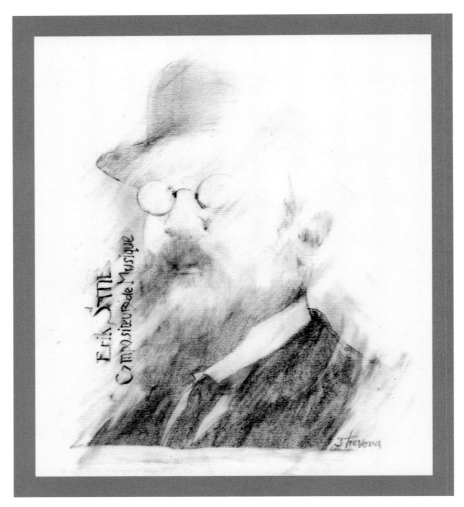

Erik Satie Compositeur de Musique (2007)
Graphite pencil
17 x 13cm (6¾ x 5in)

I have a friend who is a composer-musician. His name
is Jamie Crofts. I drew this for an event in 2007,
Satie Implications, featuring the work of Erik Satie.

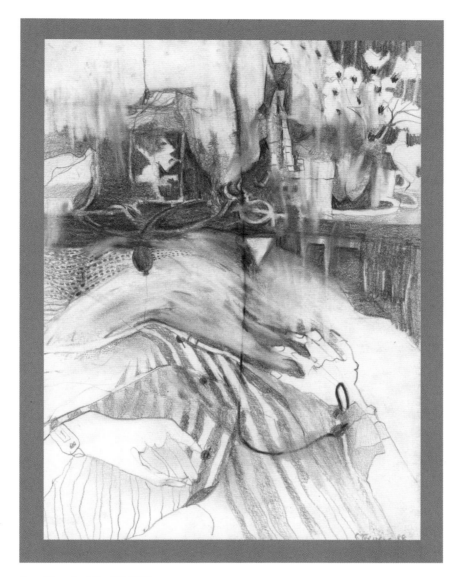

In a Hospital Bed (1988)
An assortment of pencils
20 x 14cm (8 x 5½in)

Being in hospital for two weeks was a frightening time. My only comfort was to be able to draw, even if it was only the odds and ends on a trolley at the end of my bed. I completed five drawings and, as I recovered, the pieces became less brutal and less interesting than this first piece.

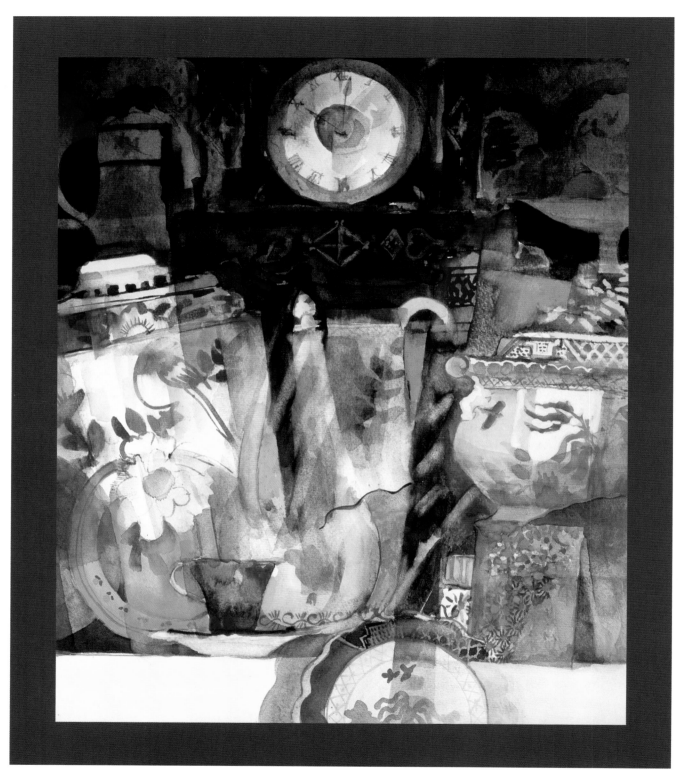

Blue China **(1989)**
Watercolour
40 x 38cm (15¾ x 15in)

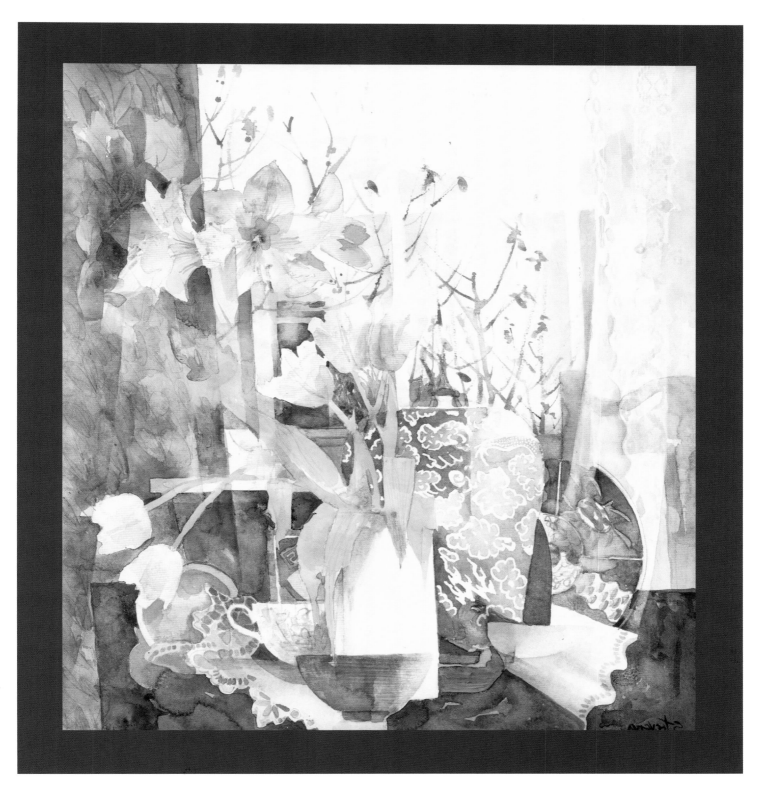

Japanese Vase and Amaryllis **(1991)**
Watercolour
43 x 43cm (17 x 17in)

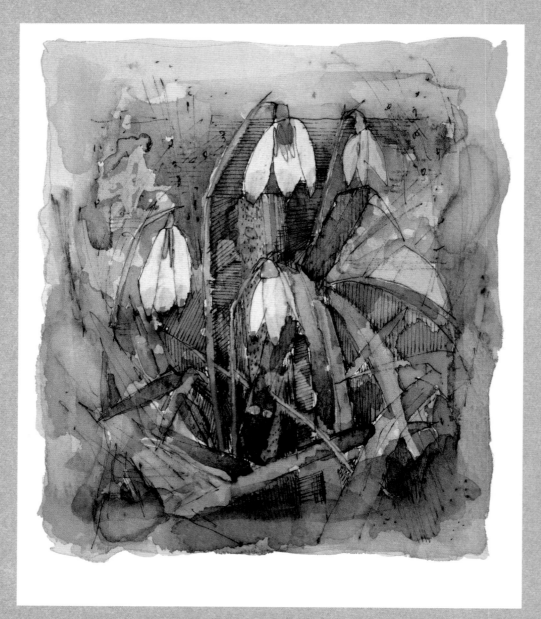

Snowdrop **(1990)**
Watercolour, pen and ink
18 x 16cm (7 x 6¼in)

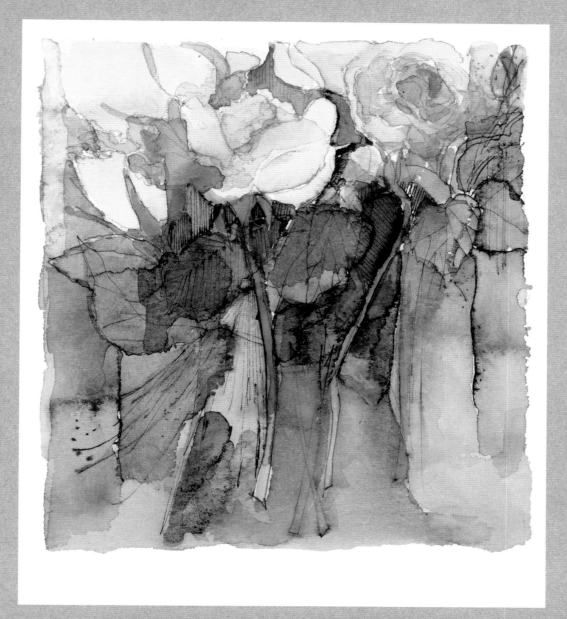

Rose **(1990)**
Watercolour, pen and ink
18 x 16cm (7 x 6¼in)

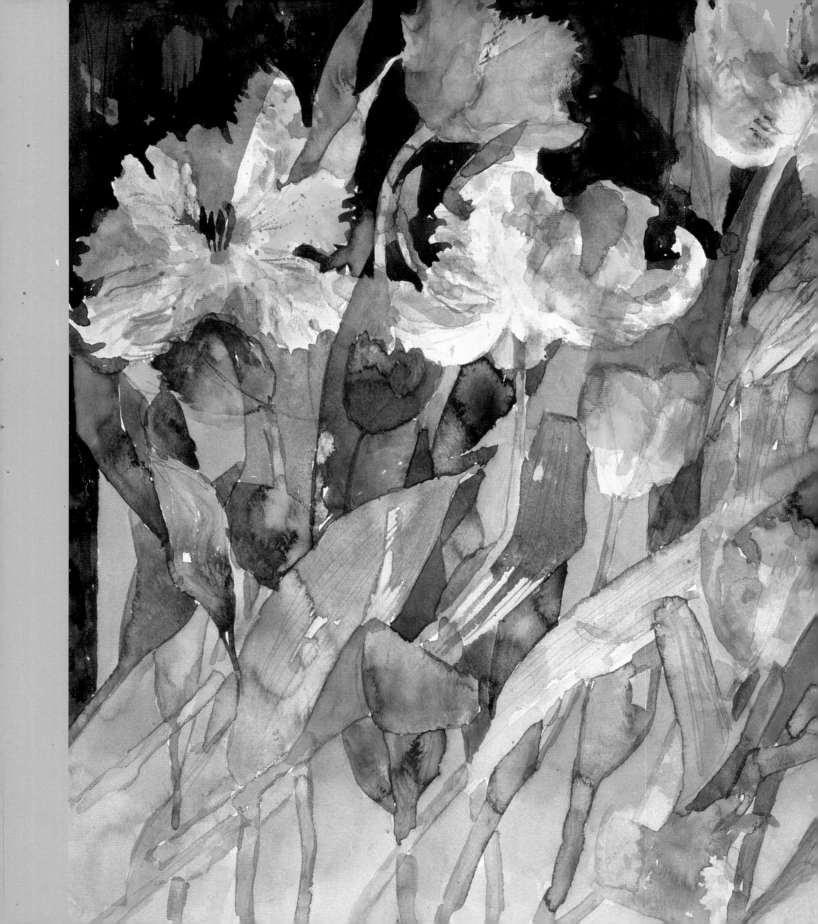

Tulipomania

Tulips are one of my favourite flowers — it seems I could be in the grip of tulipomania. Apparently in the 17th century, most of Europe, particularly Holland, was gripped by a craze for tulips which made — and then lost — many fortunes. It was popularly known as tulipomania.

True extroverts, parrot tulips are colourful, frilled and flamboyant. They so remind me of my mother...

Parrot Tulips on White Tissue Paper (1991)
Watercolour
50 x 50cm (19¾ x 19¾in)

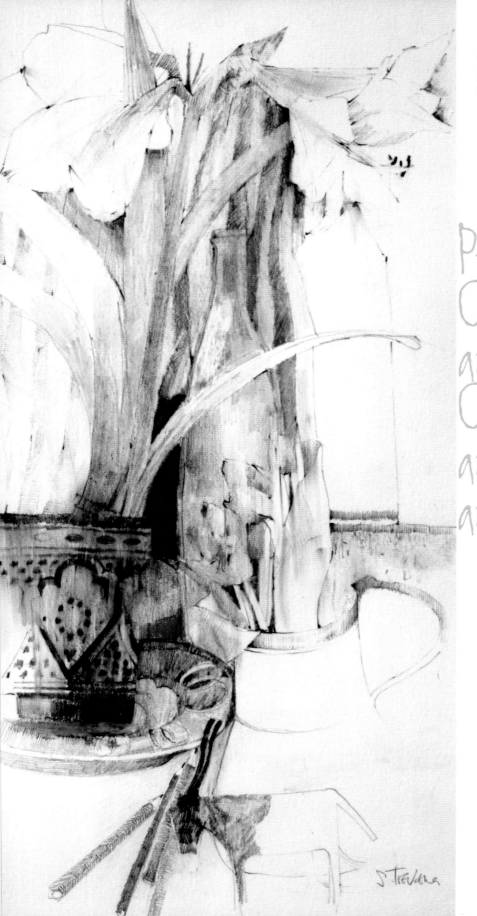

Yellow Glass Bottle **(1992)**
Pencil and crayon
39 x 28cm (15¼ x 11in)

Pencils and Crayons an
Crayons and Pencils an
and Pencils and Crayon
Crayons and Pencils an
and Pencils and Crayon
and Crayons and Pencil

Belladonna Lilies **(1992)**
Pencil and crayon
39 x 29cm (15¼ x 11½in)

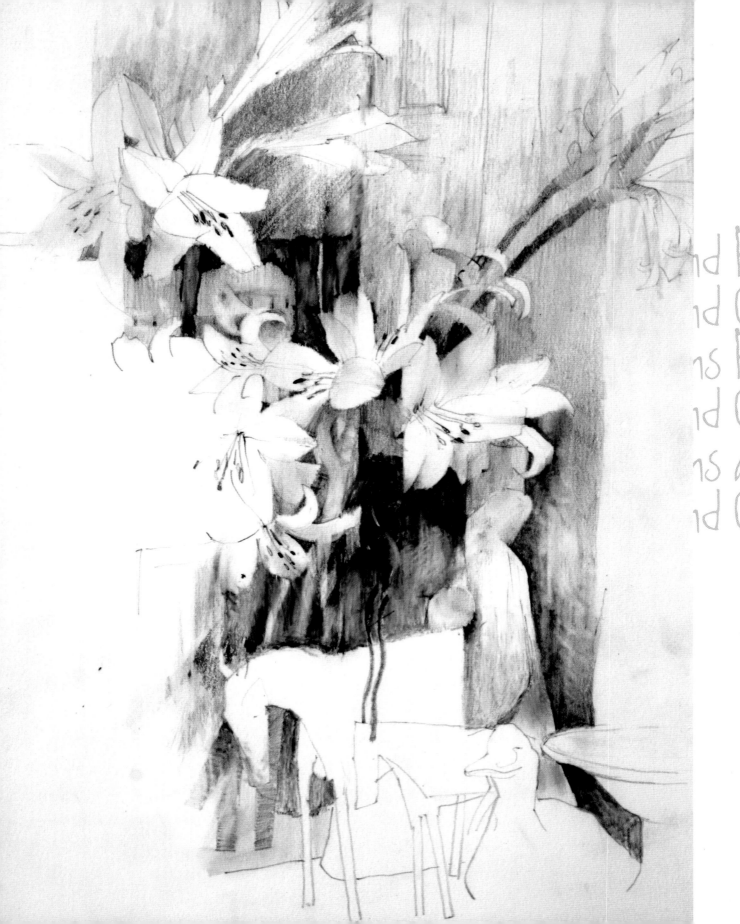

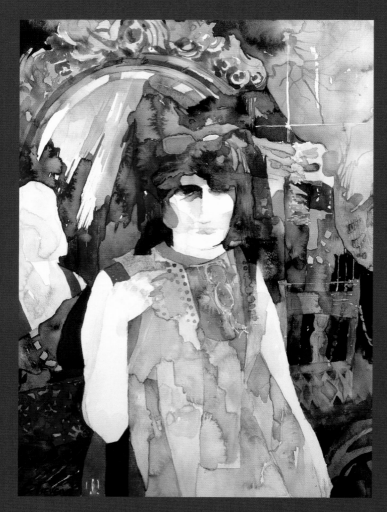

The Sky Blue Coat (1993)
Watercolour
55 x 39cm (21¾ x 15¼in)

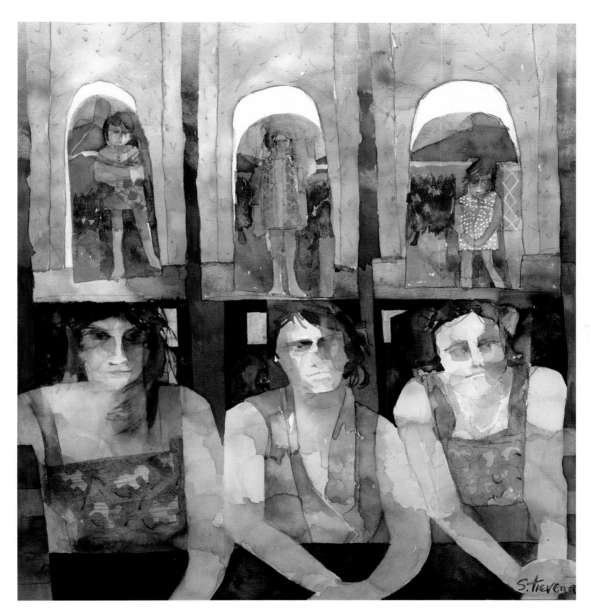

Three Friends **(1993)**
Watercolour
60 x 50cm (23½ x 19¾in)

To me, fair friend, you never can be old;
For as you were when first your eye I eyed
Such seems your beauty still.

Shakespeare

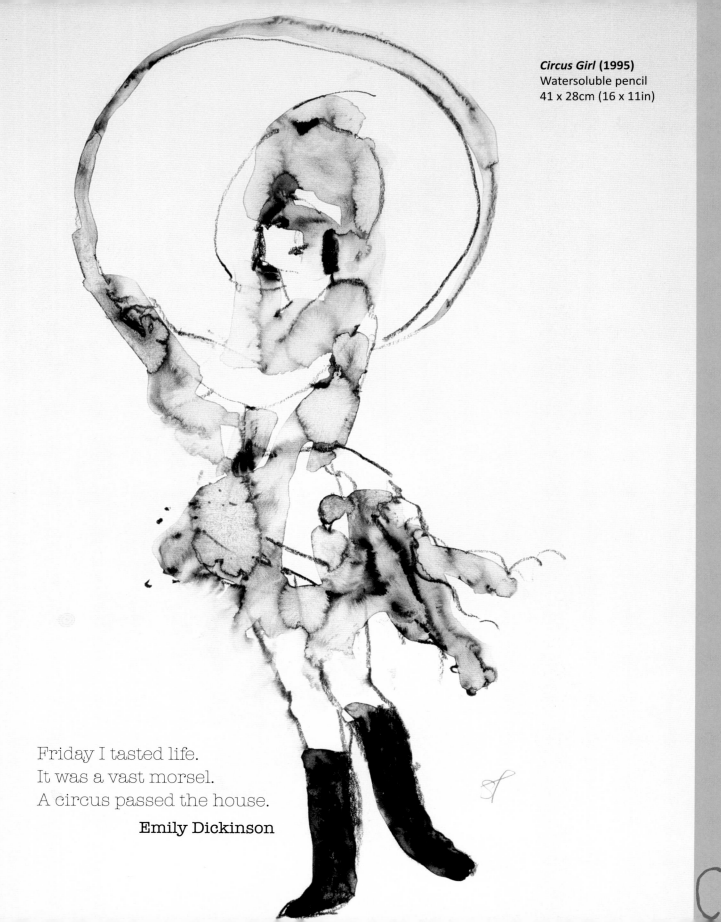

Circus Girl **(1995)**
Watersoluble pencil
41 x 28cm (16 x 11in)

Friday I tasted life.
It was a vast morsel.
A circus passed the house.

Emily Dickinson

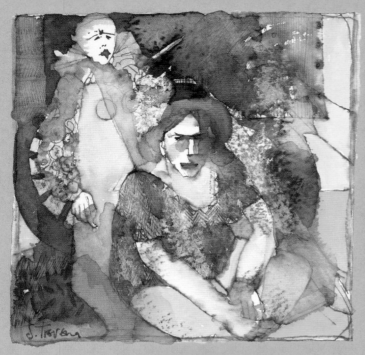

Circus Girl 9 **(1995)**
Watersoluble ink and watercolour
15 x 15cm (6 x 6in)

Circus Girl 8 **(1995)**
Watersoluble ink and
watercolour
15 x 15cm (6 x 6in)

Detail from
Circus Girl 9 **(1995)**
Watersoluble ink
and watercolour
15 x 15cm (6 x 6in)

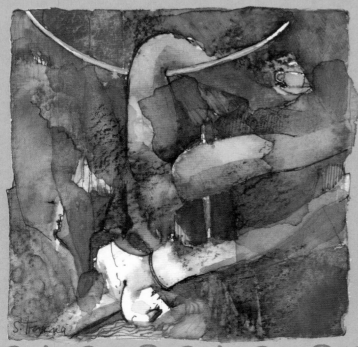

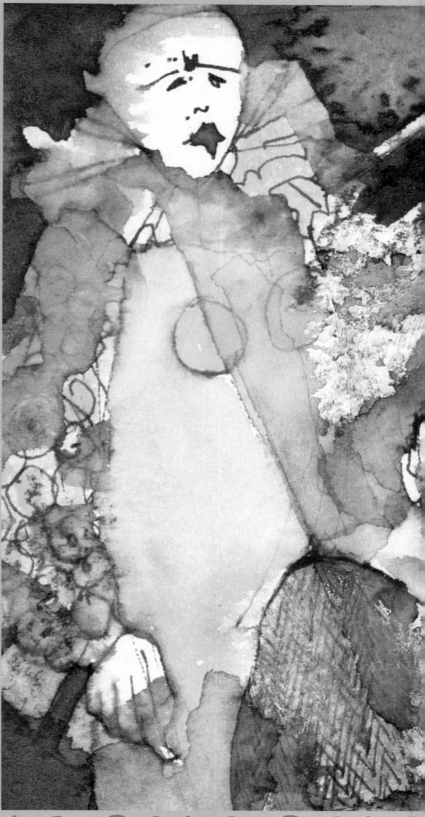

CIRCUS CIRCUS CIRCUS CIRCUS CIRC

I go to bed and start thinking of mixing colours: reds with pinks and blues with greens.

I fall asleep and dream of many strange things: being trapped in a house, chocolate and bacon, knitted ducks with deep red poppies.

The strangest thing of all is that the dream continues in full colour.

Dreaming in Colour (2012)
Pen and ink
18 x 13cm (7 x 5in)

Deep Red Poppies, **detail (1995)**
Watercolour
10 x 10cm (4 x 4in)

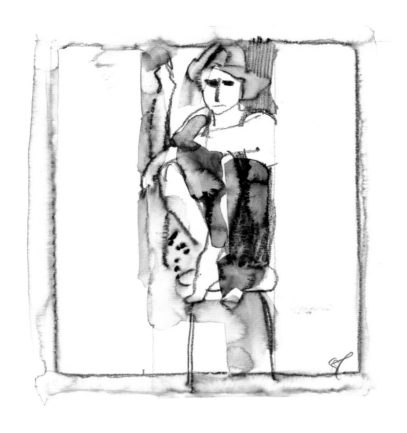

Waiting in the Wings I (1995)
Watersoluble pencil
18 x 16cm (7 x 6¼in)

My mother and grandmother were dancers in variety shows.
I have always been interested in how they dealt with the anxiety
and surge of excitement before they went into the spotlight.

Waiting in the Wings II (1995)
Watercolour and watersoluble pencil
27 x 30cm (10½ x 12in)

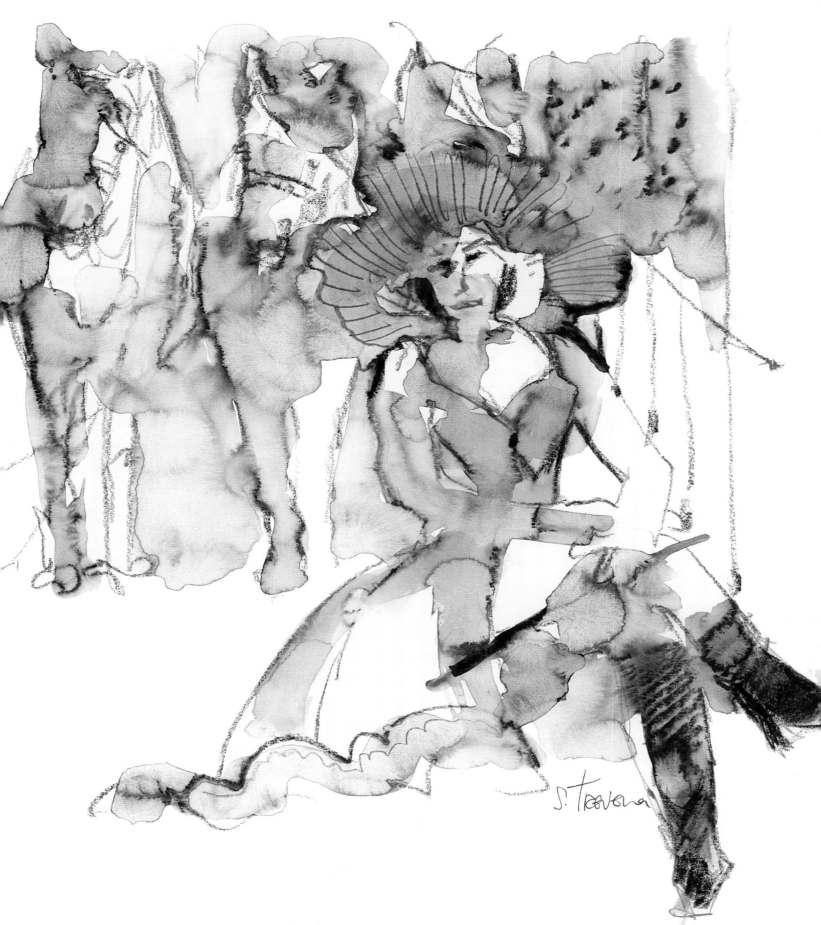

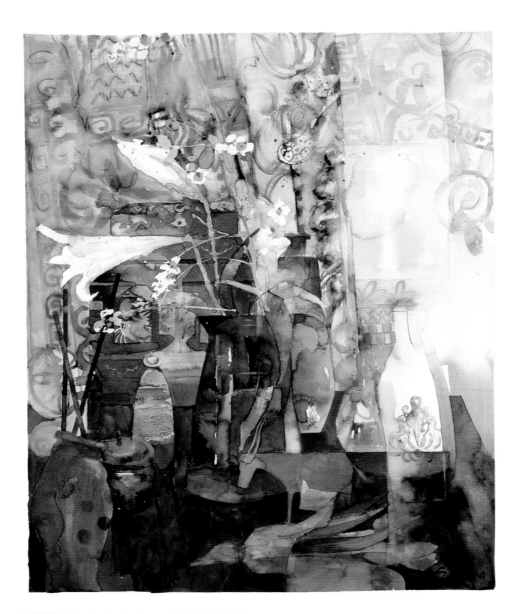

Still Life Against a Patterned Cloth **(1996)**
Watercolour
55 x 51cm (21¾ x 20in)

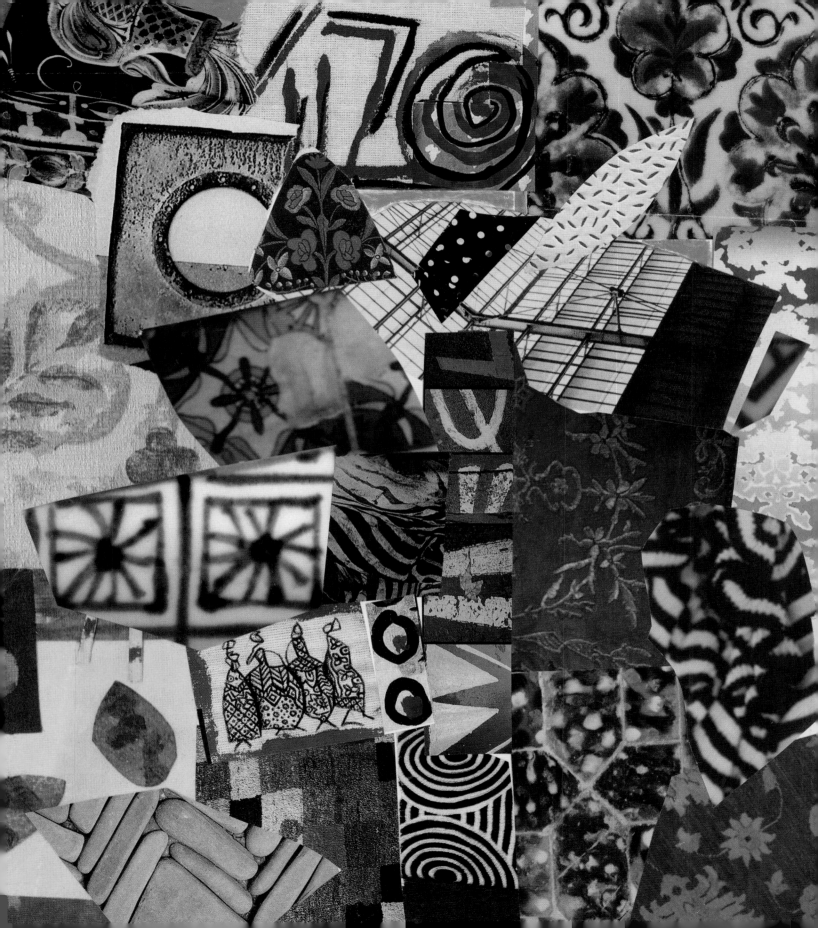

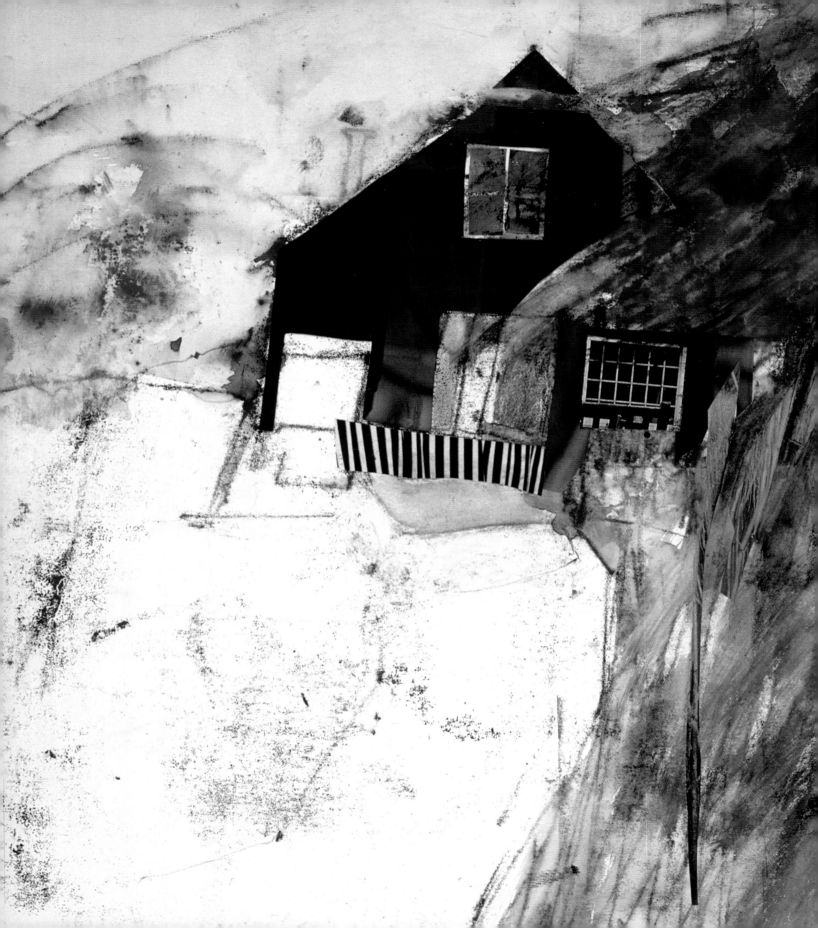

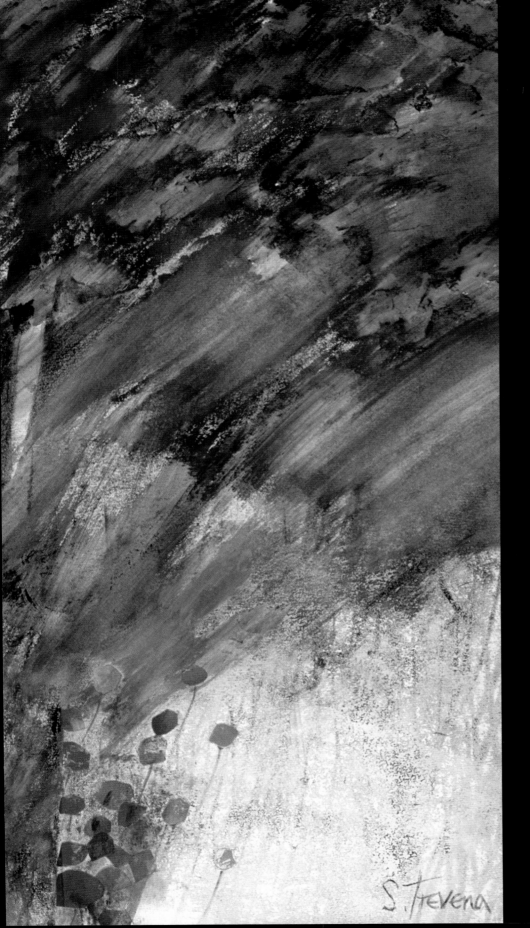

Against the snow
a house shape
lamp black strange slicing
into the trees.

House by the Forest (1998)
Mixed media
28 x 40cm (11 x 15¾in)

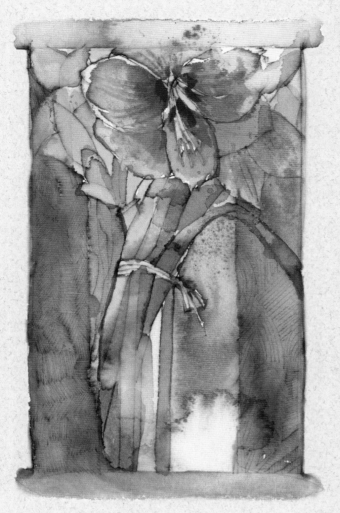

Tall Amaryllis (1998)
Watercolour
18 x 10cm (7 x 4in)

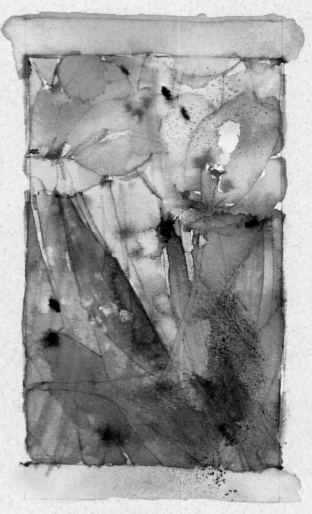

2 Orange Poppies (1998)
Watercolour
18 x 10cm (7 x 4in)

Amaryllis Poppies Magnolias Orchids

Magnolias (1998)
Watercolour
18 x 10cm (7 x 4in)

Pink Orchids (1998)
Watercolour
18 x 10cm (7 x 4in)

Amaryllis Poppies Magnolias Orchids

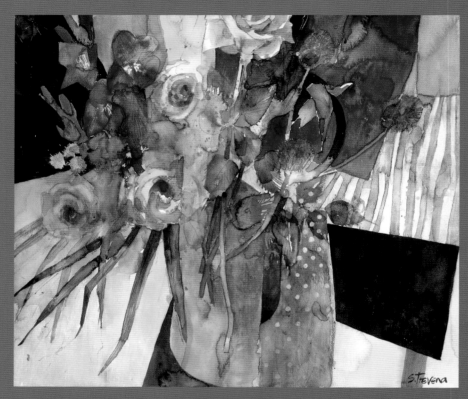

Red Flowers on a Black Table (1998)
Watercolour
48 x 53cm (19 x 21in)

Flowers give me an endless source of information for
my compositions. Spiked and curly leaves, fat and
thin petals and glorious colour combinations.

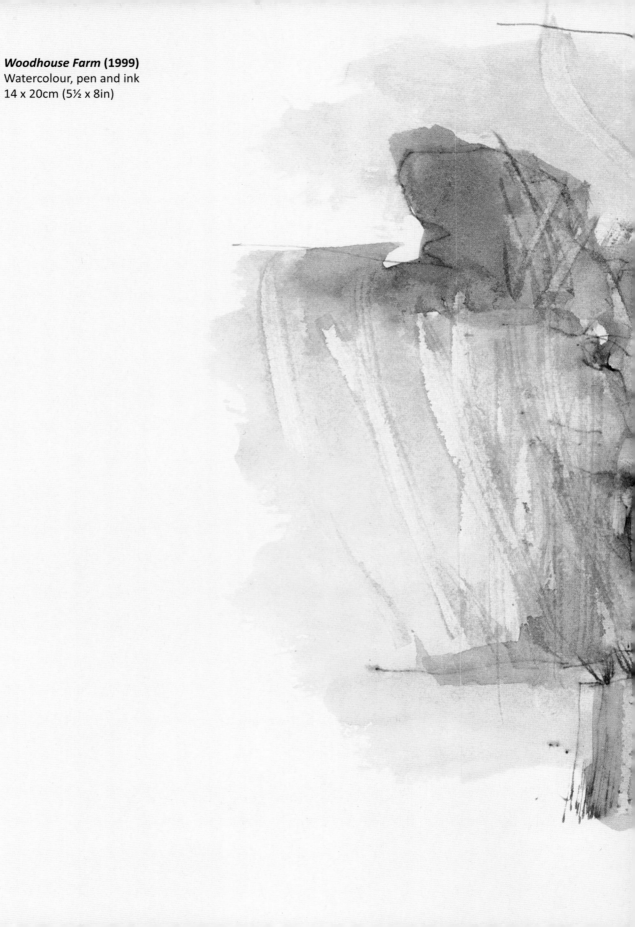

Woodhouse Farm **(1999)**
Watercolour, pen and ink
14 x 20cm (5½ x 8in)

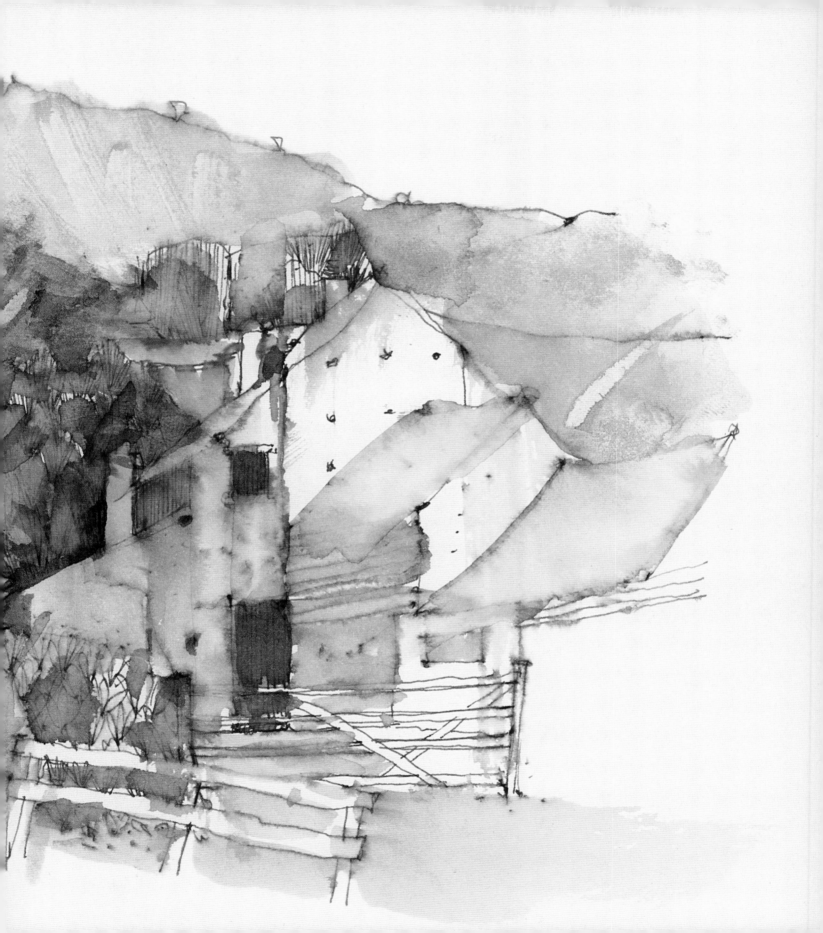

S. Trevena

They were just small buds when I bought them. Not much to look at with their straggly green fronds. Then overnight they changed, became rich velvety flowers, deep blue purple with blackberry centres and a hint of golden sunshine floating through their petals.

Jug of Anemones (1999)
Watercolour
27 x 34cm (10¾ x 13½in)

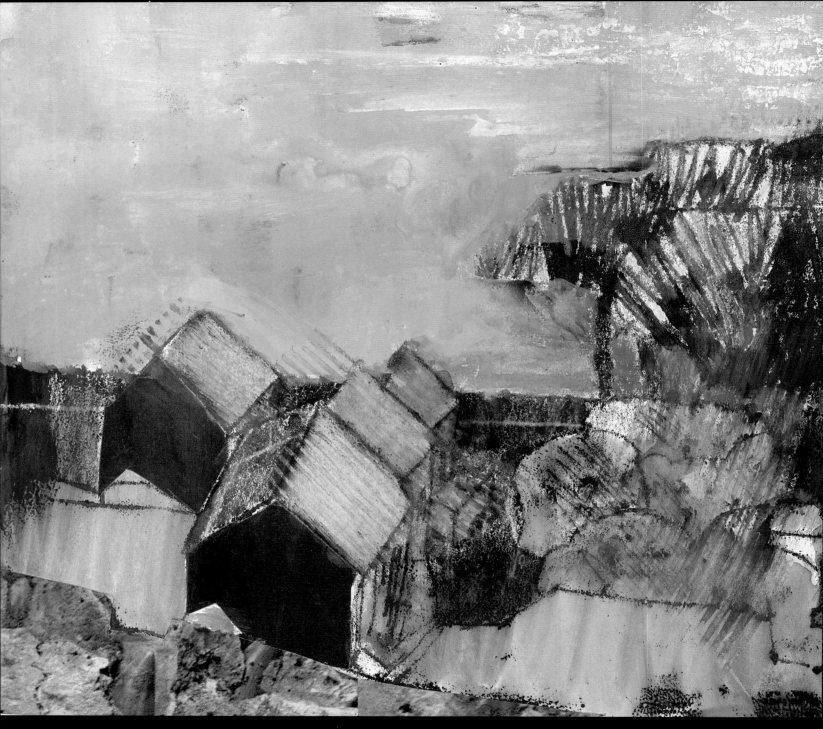

A Small Pink House **(2000)**
Monoprint, watercolour and collage
25 x 59cm (10 x 23¼in)

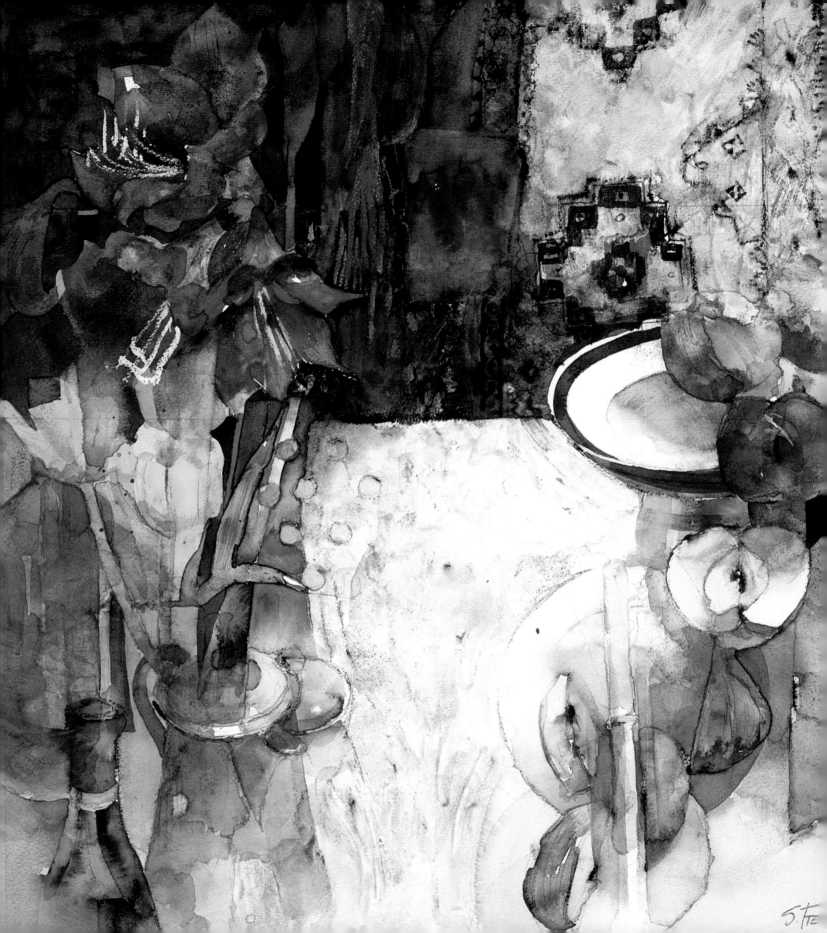

Preliminary sketch for
***Red Fruit and Flowers* (2002)**
Pen and ink
10 x 10cm (4 x 4in)

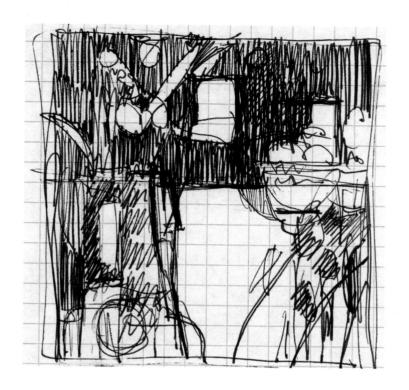

Preliminary sketch for
***Red Fruit and Flowers* (2002)**
Pencil
10 x 10cm (4 x 4in)

***Red Fruit and Flowers* (2002)**
Watercolour
55 x 50cm (21¾ x 19¾in)

Tuscan Villas and Cyprus Trees (2001)
Watercolour
7 x 13cm (2¾ x 5in)

Tuscan Landscape (2001)
Watercolour
7 x 13cm (2¾ x 5in)

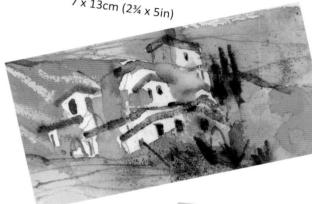

Tuscan Rooftops (2001)
Watercolour
7 x 13cm (2¾ x 5in)

Roma, Piazza Di Spagna (2000)
Watercolour, pen and ink
12 x 10cm (4¾ x 4in)

Espresso, Tuscany (1999)
Watercolour, pen and ink
10 x 10cm (4 x 4in)

Tuscan Vineyards (2001)
Watercolour
7 x 13cm (2¾ x 5in)

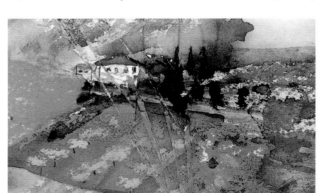

Tuscan Fields (2001)
Watercolour
7 x 13cm (2¾ x 5in)

Tuscan Villa (2001)
Watercolour
7 x 13cm (2¾ x 5in)

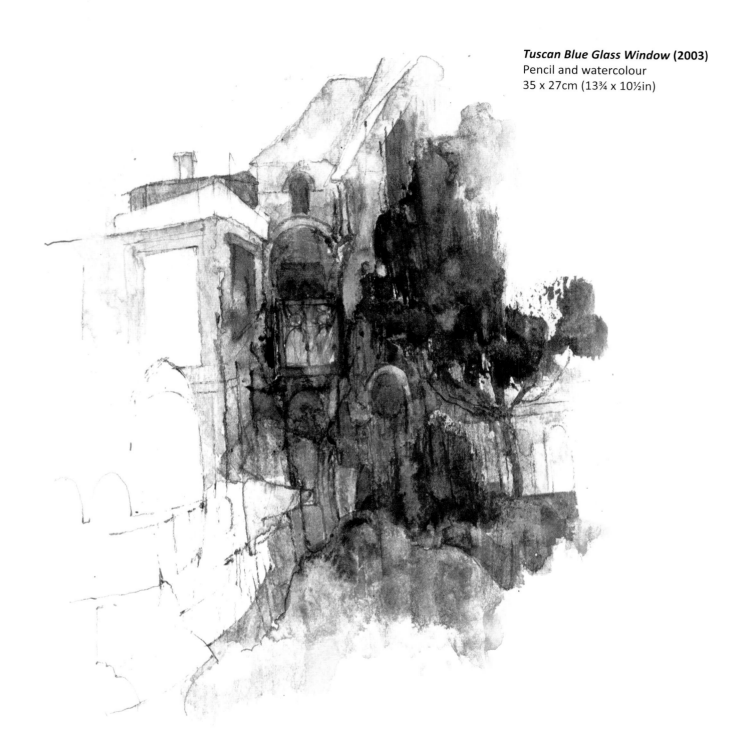

Tuscan Blue Glass Window **(2003)**
Pencil and watercolour
35 x 27cm (13¾ x 10½in)

With love from Tuscany – the
inspiration of Tuscany is endless.

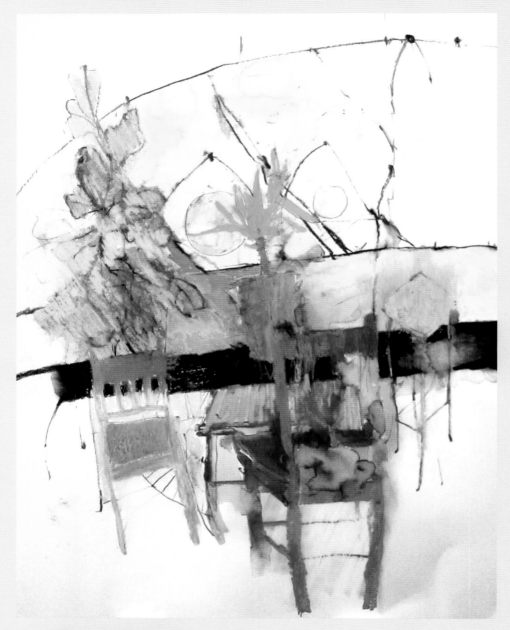

Yellow Table with Plant (2005)
Mixed media
56 x 42cm (22 x 16½in)

Sometimes intuition gets into gear and occasionally I produce a piece of work that seems to drift into a picture that a five-year-old would have drawn. I really enjoy this – it's like opening a door into painting possibilities.

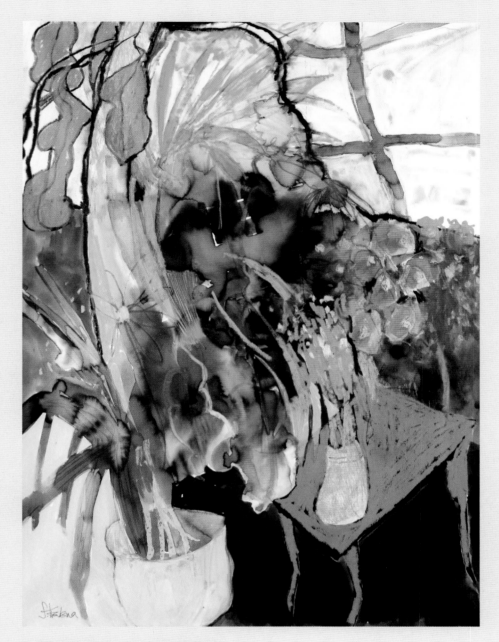

Sunlight in the Conservatory (2007)
Mixed media
56 x 42cm (22 x 16½in)

This painting offered me an opportunity to try a different style.
It's lively and gestural, painted quickly with a lot of strong,
intuitive marks.

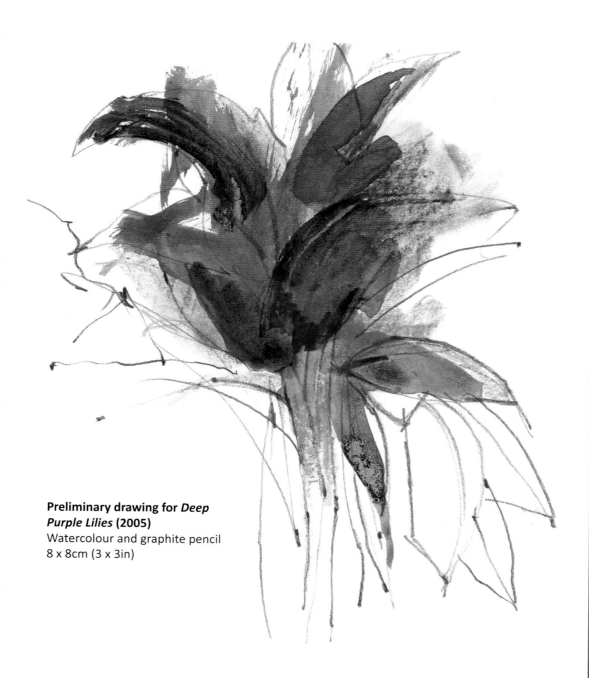

Preliminary drawing for *Deep Purple Lilies* (2005)
Watercolour and graphite pencil
8 x 8cm (3 x 3in)

Deep purple lilies in a bucket outside
a florist's shop are hard to pass by.
My first thought, 'How many shall I buy?';
my second, 'How do I mix that colour?'.

***Deep Purple Lilies* (2005)**
Watercolour and
graphite pencil
48 x 38cm (19 x 15in)

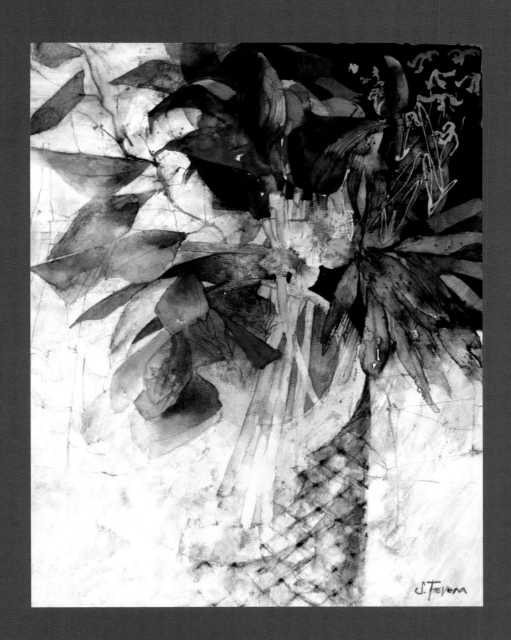

Preliminary sketch for
*Two Clocks and a Pea
Pod Man* **(2006)**
Pen and ink
25 x 20cm (10 x 8in)

I have done hundreds of paintings but only count about five of them as my best work. This painting is on that list.

Preliminary sketch for
*Two Clocks and a Pea
Pod Man* **(2006)**
Pen and ink
20 x 8cm (8 x 3¼in)

*Two Clocks and a
Pea Pod Man* **(2006)**
Watercolour and
graphite pencil
48 x 38cm (19 x 15in)

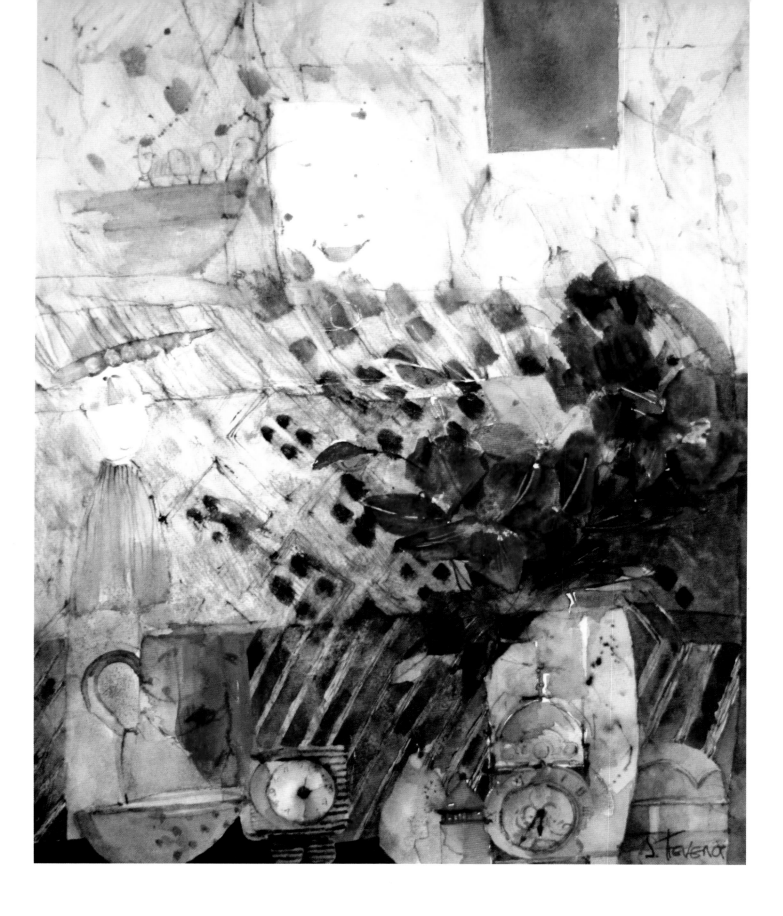

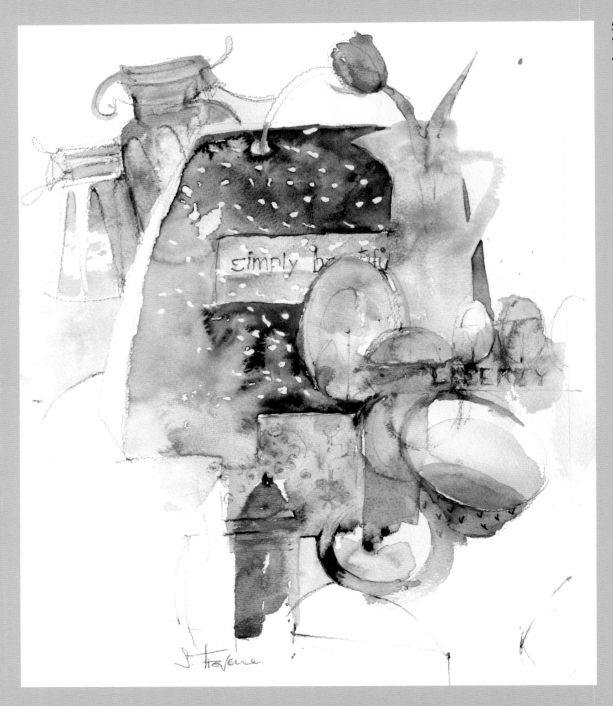

Sketch for *Still Life* (2011)
Watercolour and pencil
43 x 34cm (17 x 13½in)

This quick sketch was made without a still-life set up. I started with a small object, the pepper pot in the foreground, then picked random props from my studio shelf and added them to the composition one by one, rather like working a jigsaw puzzle.

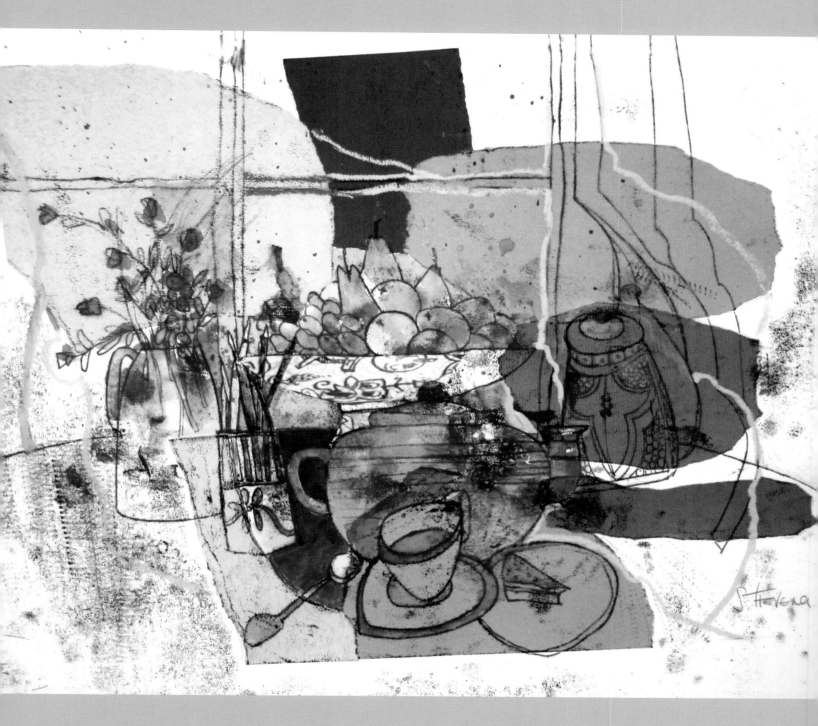

Pink Teapot and Fruit (2006)
Monoprint and mixed media
30 x 40cm (12 x 15¾in)

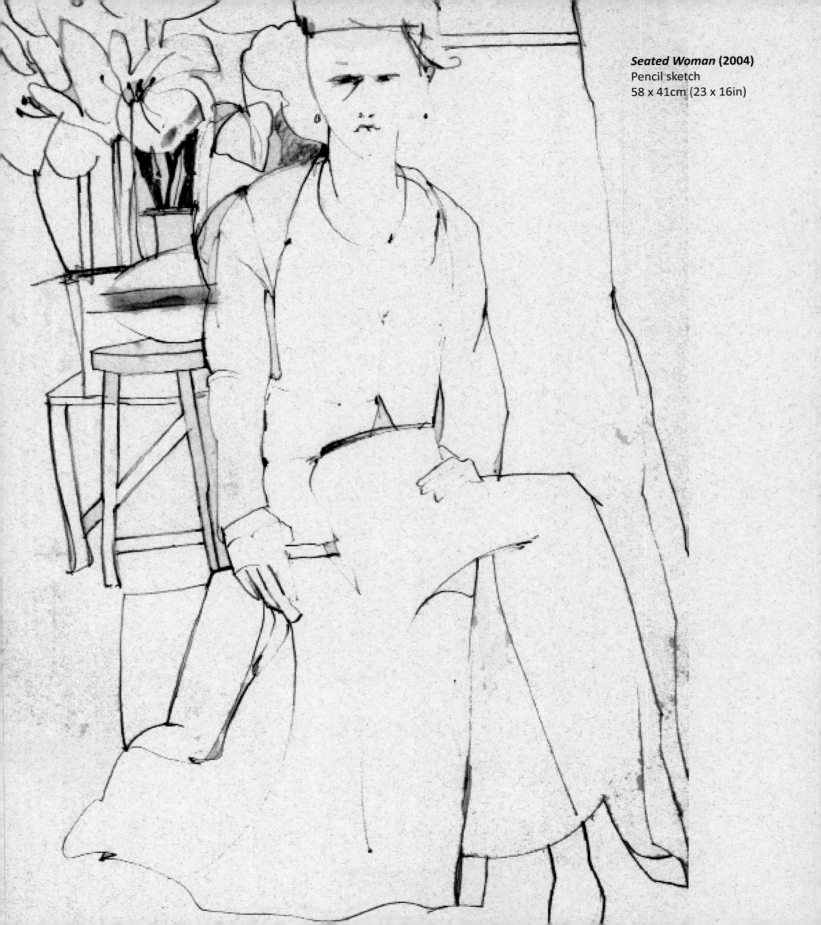

Seated Woman **(2004)**
Pencil sketch
58 x 41cm (23 x 16in)

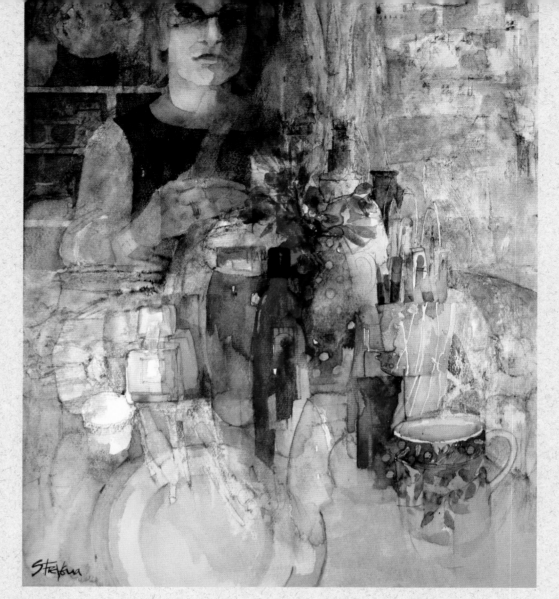

Painting My Dressing Table (2007)
Watercolour and graphite pencil
46 x 38cm (18 x 15in)

I don't know why I put myself through these challenges but this painting is probably the only successful attempt I've had at doing a self-portrait. I set up the objects on my dressing table so that I could peer at myself in the mirror. So here it is, neither a still life nor a portrait, but perhaps a bit of both. The bewildered look on my face says it all – 'Do I really have to finish this? Isn't it time for tea?'

Sketch for _Musical Flowers_ (2007)
Pen and ink
6 x 6cm (2½ x 2½in)

This is the tiny sketch I made for
Musical Flowers. In the finished
painting I left out the piece of carpet
and added three chairs going round
the spray of flowers.

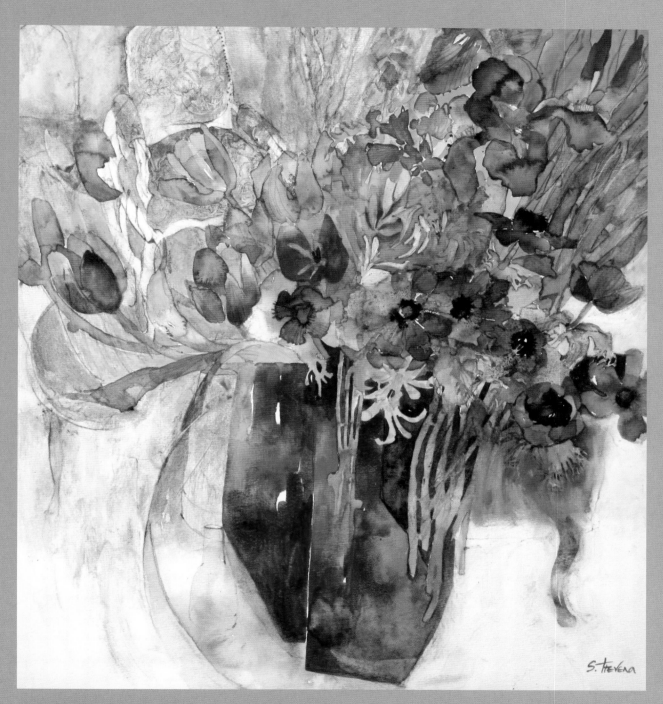

Musical Flowers **(2007)**
Watercolour and graphite pencil
52 x 48cm (20½ x 19in)

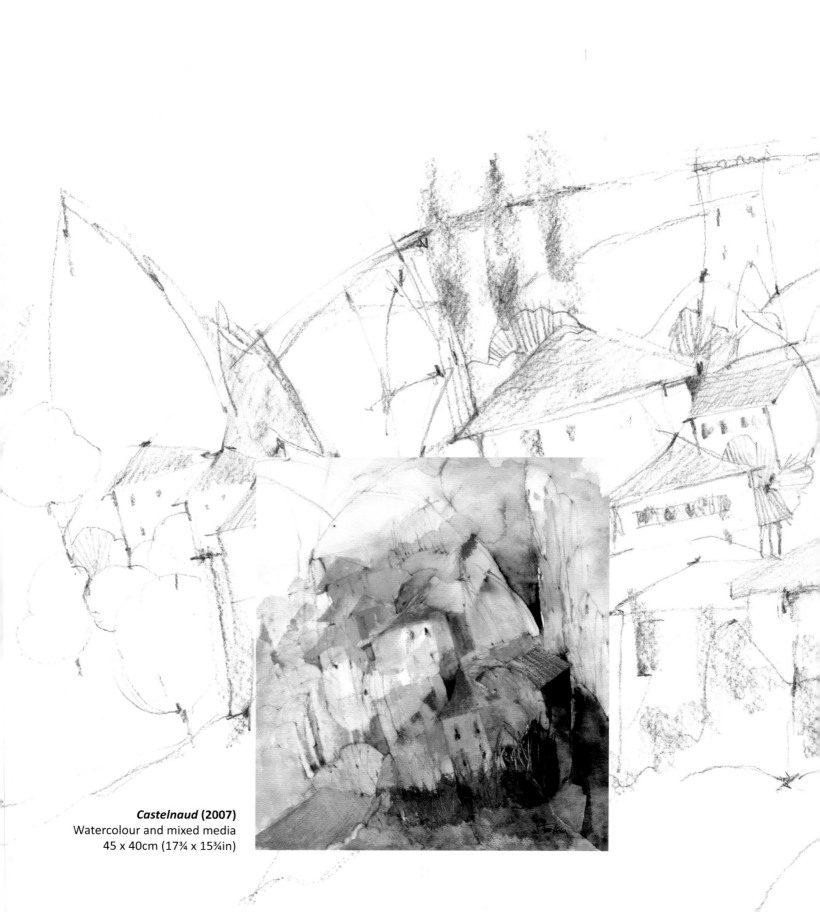

Castelnaud (2007)
Watercolour and mixed media
45 x 40cm (17¾ x 15¾in)

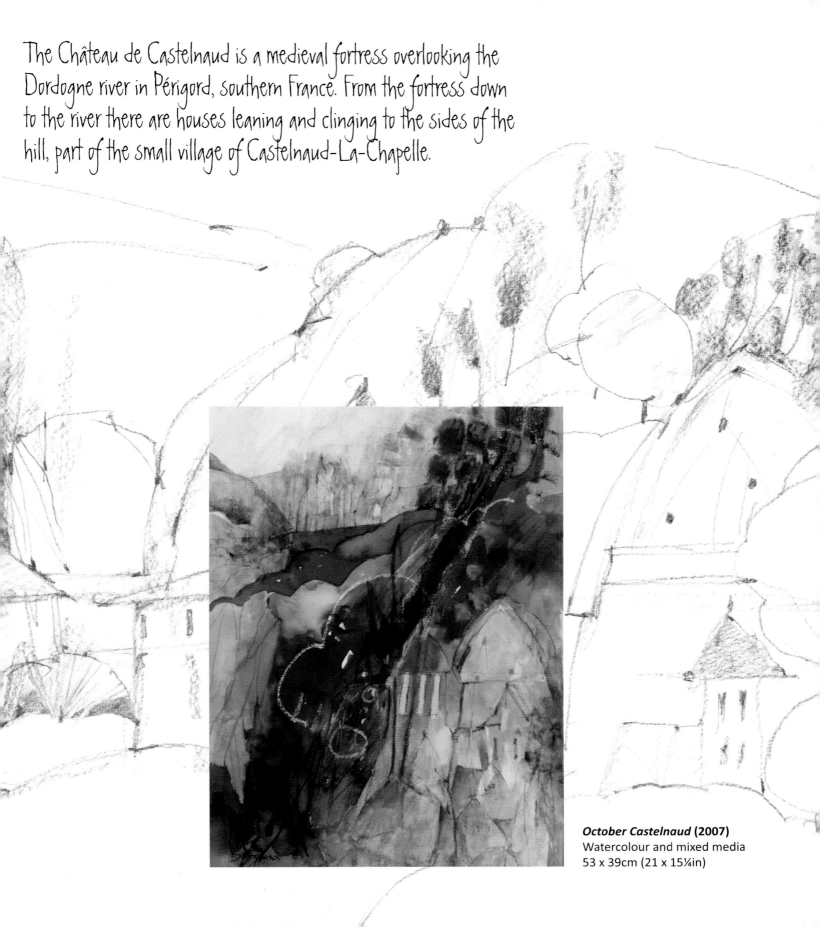

The Château de Castelnaud is a medieval fortress overlooking the Dordogne river in Périgord, southern France. From the fortress down to the river there are houses leaning and clinging to the sides of the hill, part of the small village of Castelnaud-La-Chapelle.

October Castelnaud **(2007)**
Watercolour and mixed media
53 x 39cm (21 x 15¼in)

We drove through France
Calais to Toulon
Passed small villages
Fields of vines and sunflowers
All rushing past our windows
Until they were no more than a blur.
There was a pink sunrise
Then a golden evening glow
That turned quite suddenly
Into an inky blue night sky.

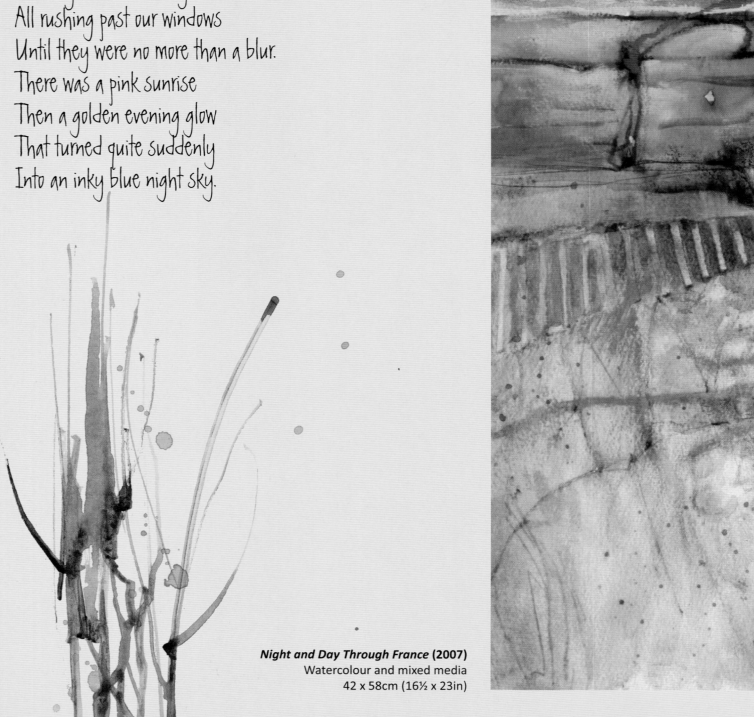

Night and Day Through France (2007)
Watercolour and mixed media
42 x 58cm (16½ x 23in)

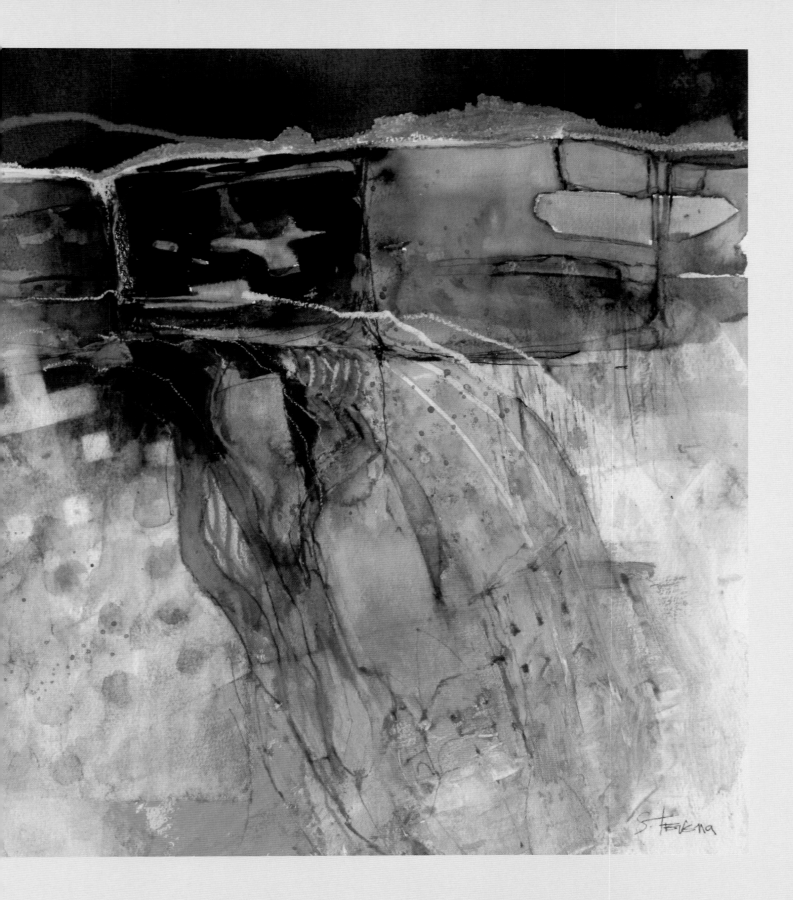

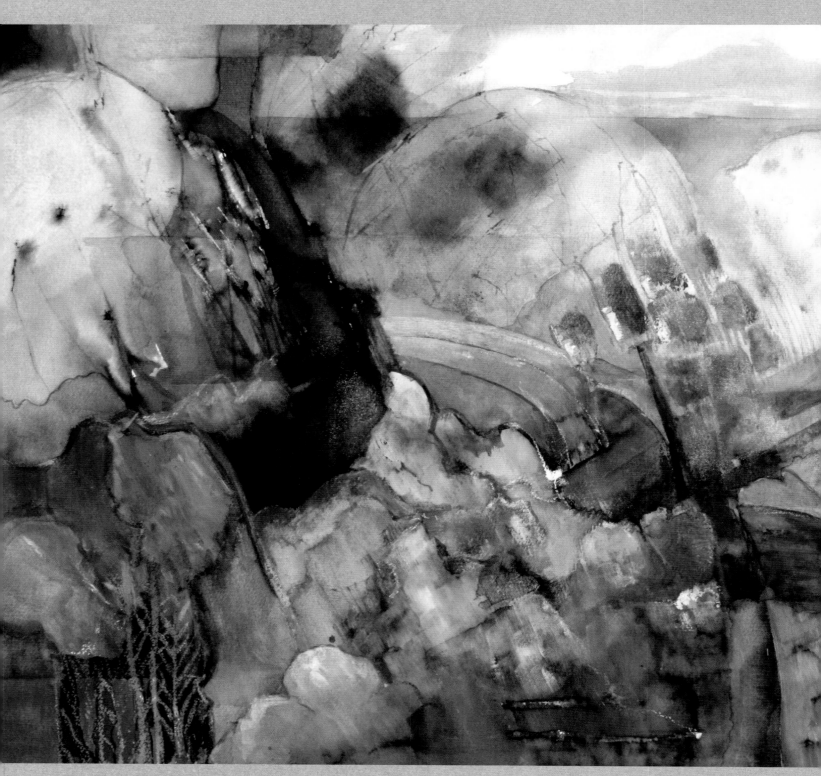

***Frosty Morning at Rauffet* (2007)**
Watercolour and oil pastel
49 x 63cm (19¼ x 24¾in)

***Frosty Morning at Rauffet,* detail (2007)**
Watercolour and oil pastel
49 x 63cm (19¼ x 24¾in)

Still life for me is working with the familiar, recognizable object, be it isolated or in a group; the need to put objects together in such a way that changes their familiar ordinariness into a kind of transparent film of reality.

Green Tea and Wine **(2008)**
Watercolour and graphite pencil
52 x 44cm (20½ x 17¼in)

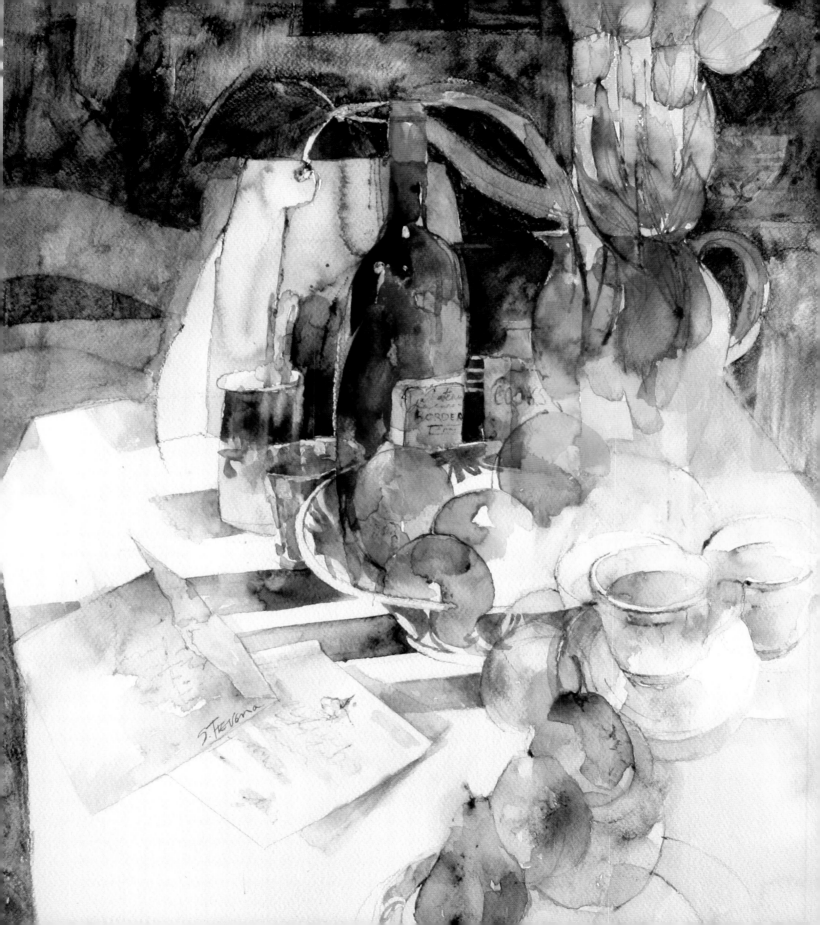

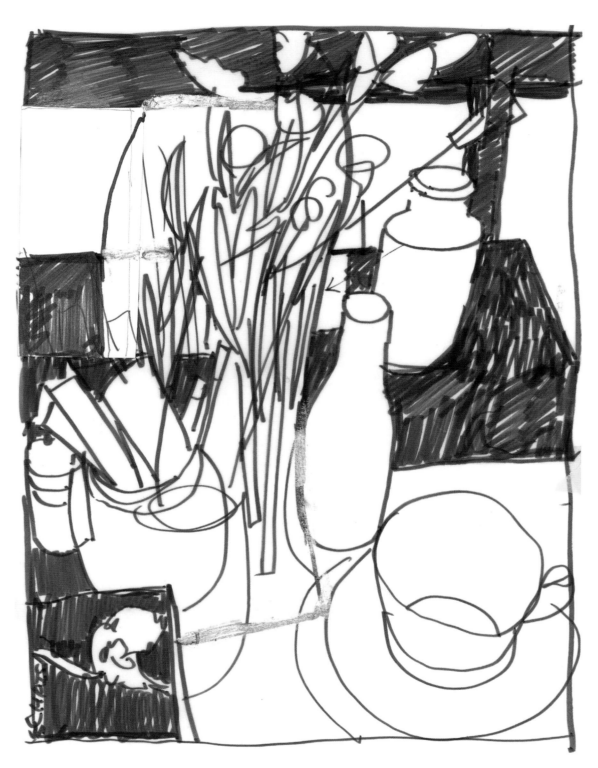

Sketch for *Carnations in a Yellow Vase* **(2008)**
Felt tip pen
20 x 26cm (8 x 10¼in)

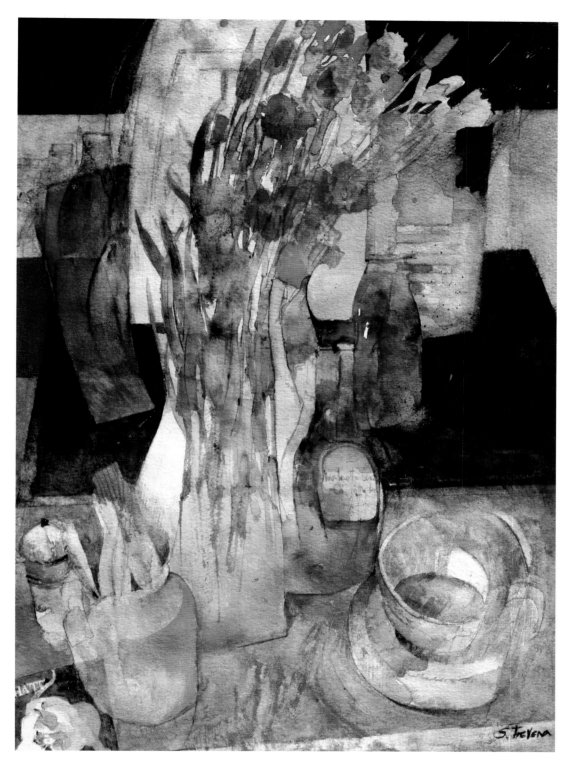

Carnations in a Yellow Vase (2008)
Watercolour
50 x 36cm (19¾ x 14in)

Pink Still Life at Rauffet **(2008)**
Watercolour and graphite pencil
45 x 38cm (17¾ x 15in)

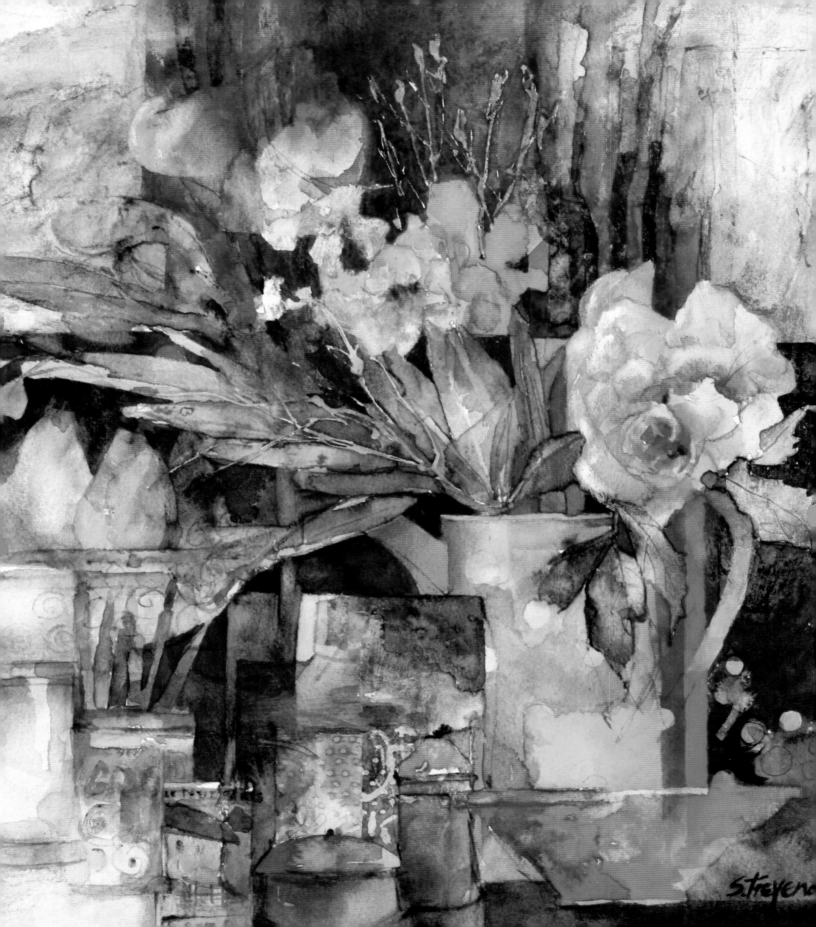

S.Treyen

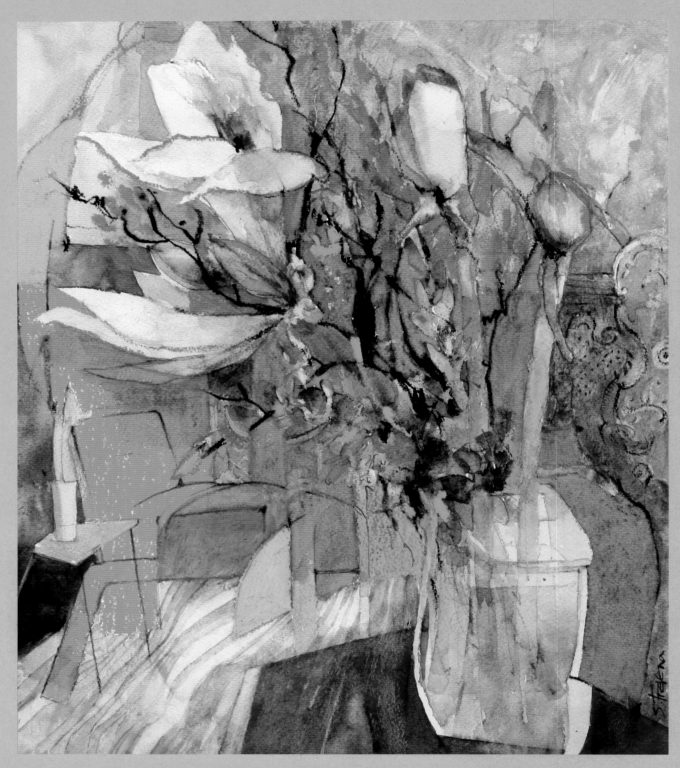

***In the Pink* (2009)**
Watercolour, oil pastel and graphite pencil
45 x 39.5cm (17¾ x 15½in)

orange + pink
pink & orange
& turquoise

At the age of thirteen I insisted on having my bedroom painted pink and orange.

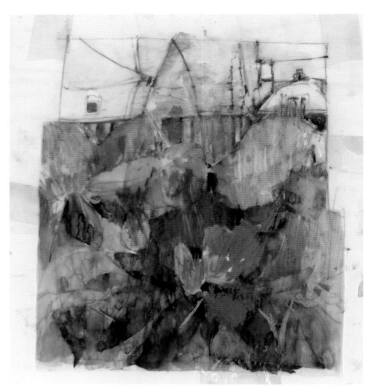

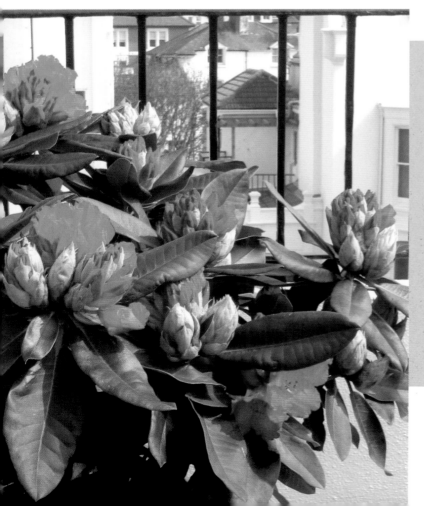

We bought this pot of rhododendrons when it had tight buds and the promise of pink and purple flowers. I could see it growing from my kitchen window and I loved the combination of organic flower shapes against the railings and the rooftops.

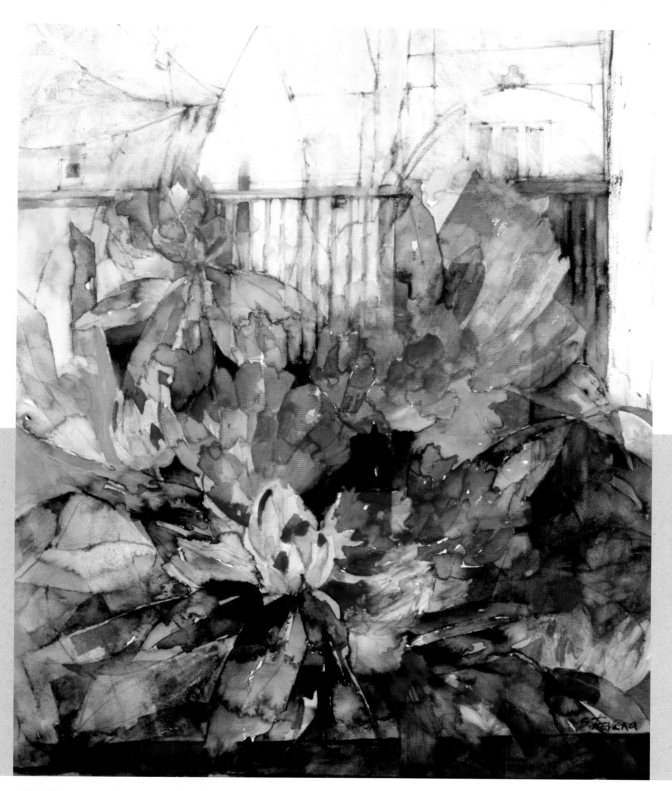

Pink Flowers on the Terrace **(2009)**
Watercolour and graphite pencil
60 x 50cm (23½ x 19¾in)

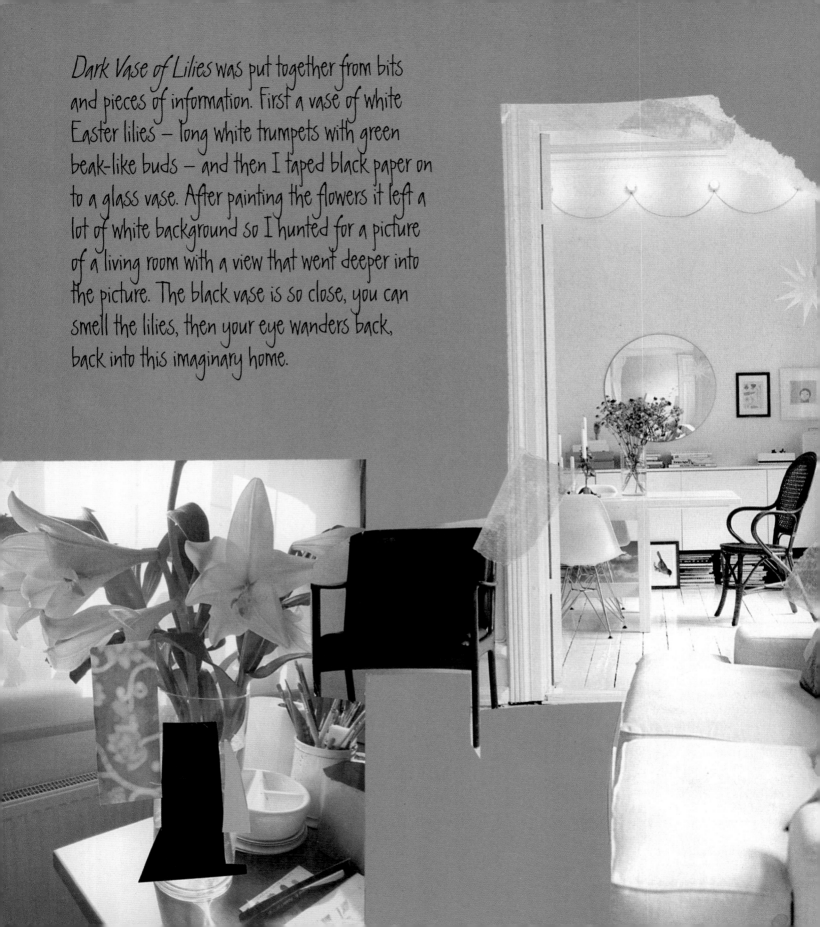

Dark Vase of Lilies was put together from bits and pieces of information. First a vase of white Easter lilies – long white trumpets with green beak-like buds – and then I taped black paper on to a glass vase. After painting the flowers it left a lot of white background so I hunted for a picture of a living room with a view that went deeper into the picture. The black vase is so close, you can smell the lilies, then your eye wanders back, back into this imaginary home.

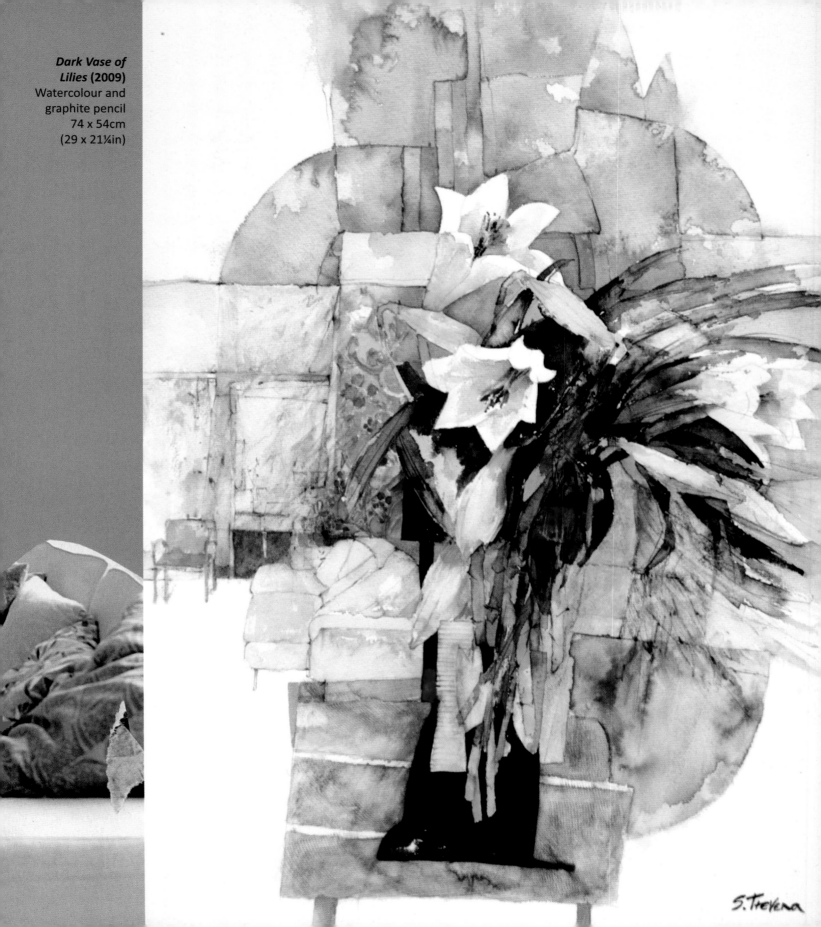

Dark Vase of Lilies (2009)
Watercolour and graphite pencil
74 x 54cm
(29 x 21¼in)

S.Trevena

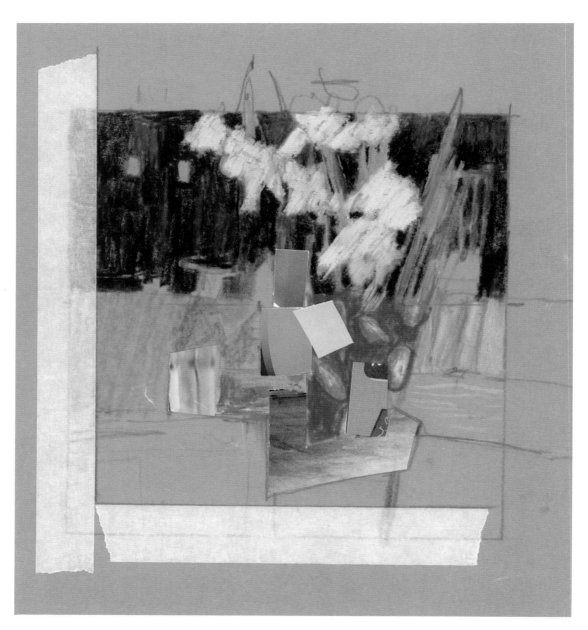

Sketch for *The Magic Vase* (2009)
Collage, crayon and pencil
13 x 13cm (5 x 5in)

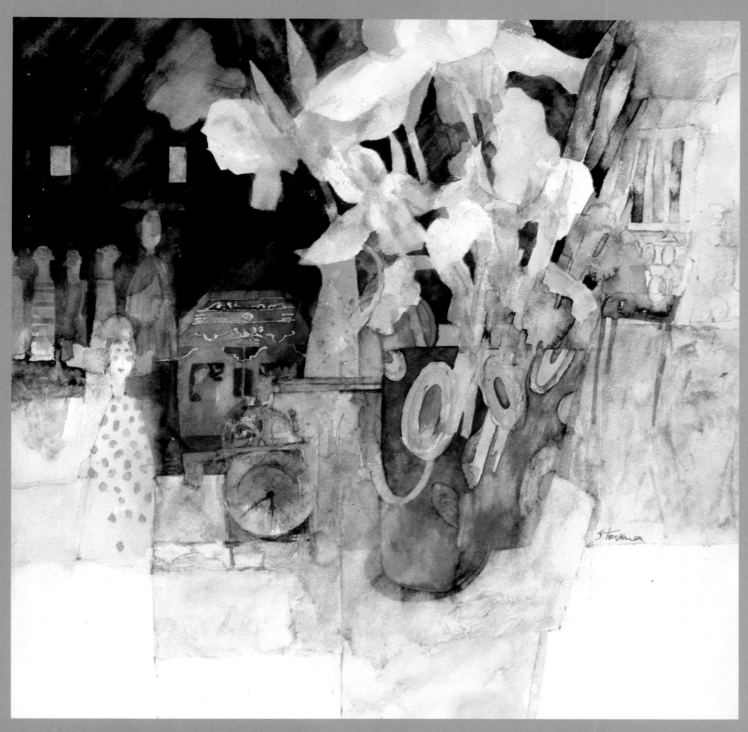

The Magic Vase **(2009)**
Watercolour
52 x 52cm (20½ x 20½in)

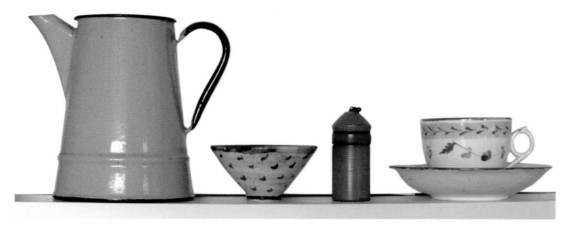

Favourite objects on the studio shelf

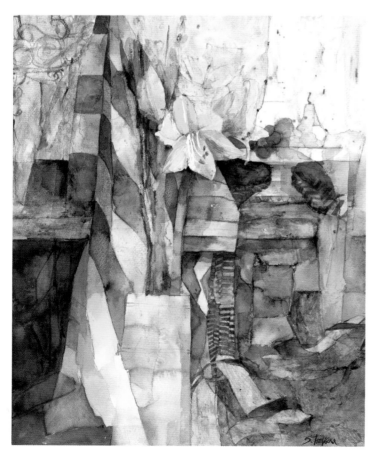

Striped Coat and Candy Pink Shoes (2004)
Watercolour
48.5 x 38.5cm (19 x 15¼in)

Many of the objects I have collected over the years have become firm favourites and appear in several of my paintings. The striped cloth, wonderful for making linear shapes, appears in both of these paintings.

*An Orange, Cup and
Some Pears* (2009)
Watercolour
46 x 39cm (18 x 15¼in)

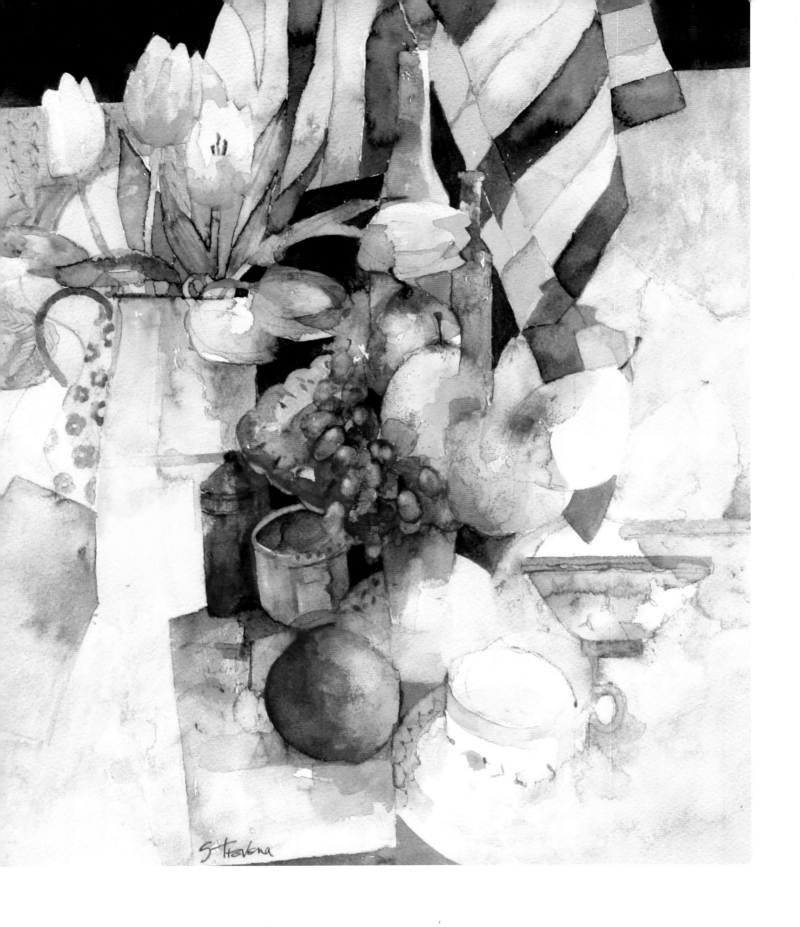

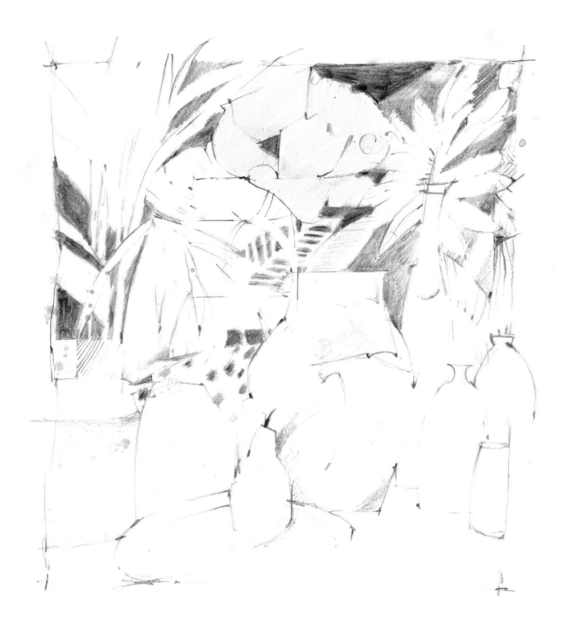

Sketch for *Paper Flowers in a French Vase* (2010)
Pencil
18 x 20cm (7 x 8in)

I have a collection of paper flowers, which I find very useful. The most useful thing is they don't fade away when I'm only halfway through the painting.

<div align="right">

***Paper Flowers in a
French Vase* (2010)**
Watercolour
46 x 30cm (18 x 12in)

</div>

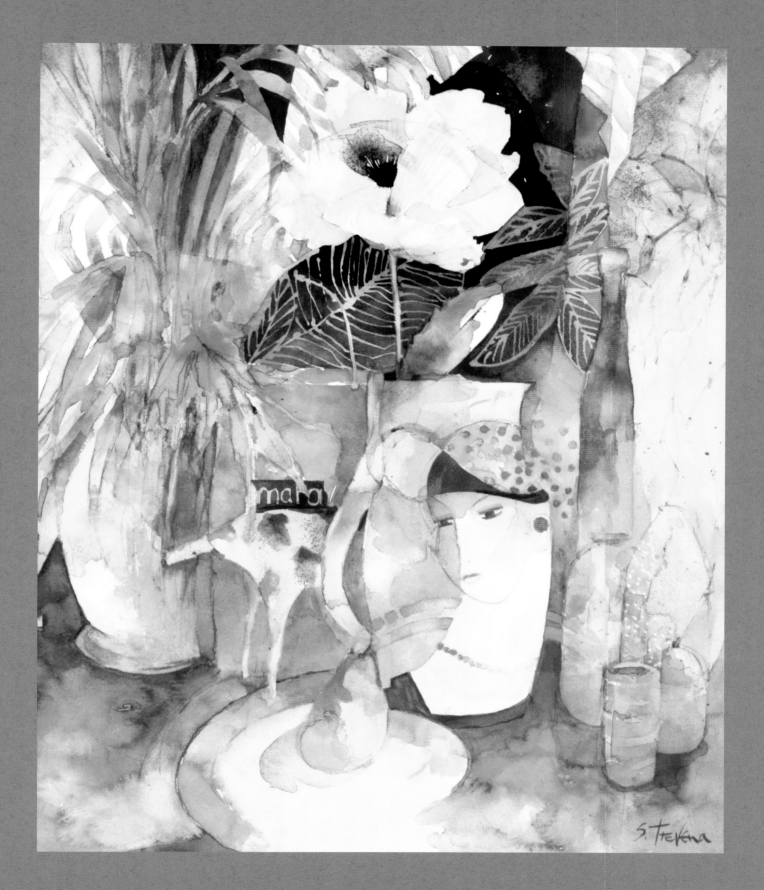

S. Trevena

Sketch for *Yellow Jug of Anemones* **(2010)**
Coloured pencil
8 x 8cm (3 x 3in)

When I start a painting, I don't depend on a detailed drawing on the watercolour paper. I prefer to paint without a lifeline. This leaves me free to change my concept in mid-stream. This little scrap of paper from a lined notepad was my starting point here – the finished painting developed into a much better composition.

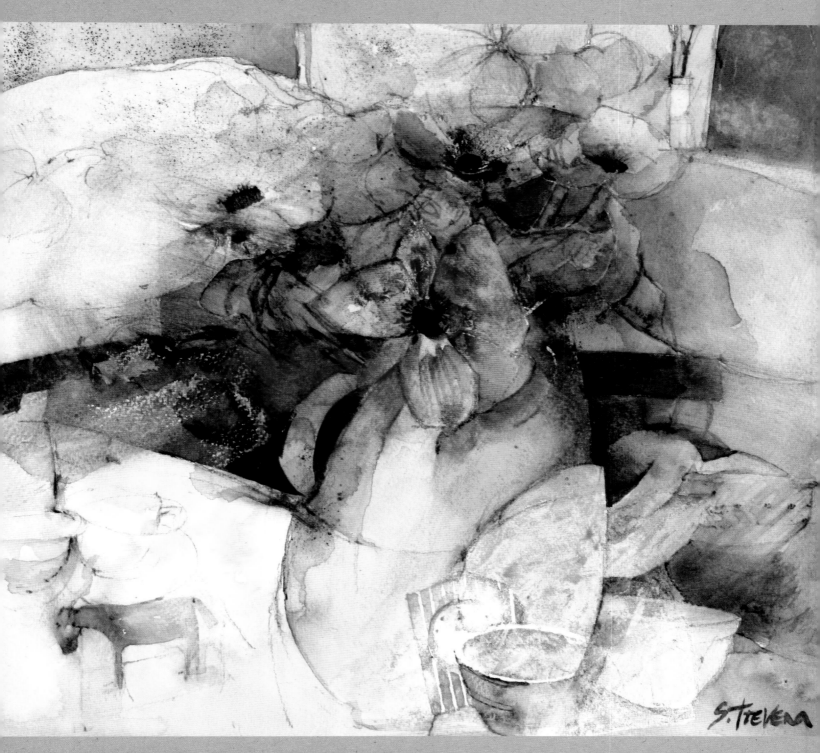

Yellow Jug of Anemones **(2010)**
Watercolour and graphite pencil
30 x 35cm (12 x 13¾in)

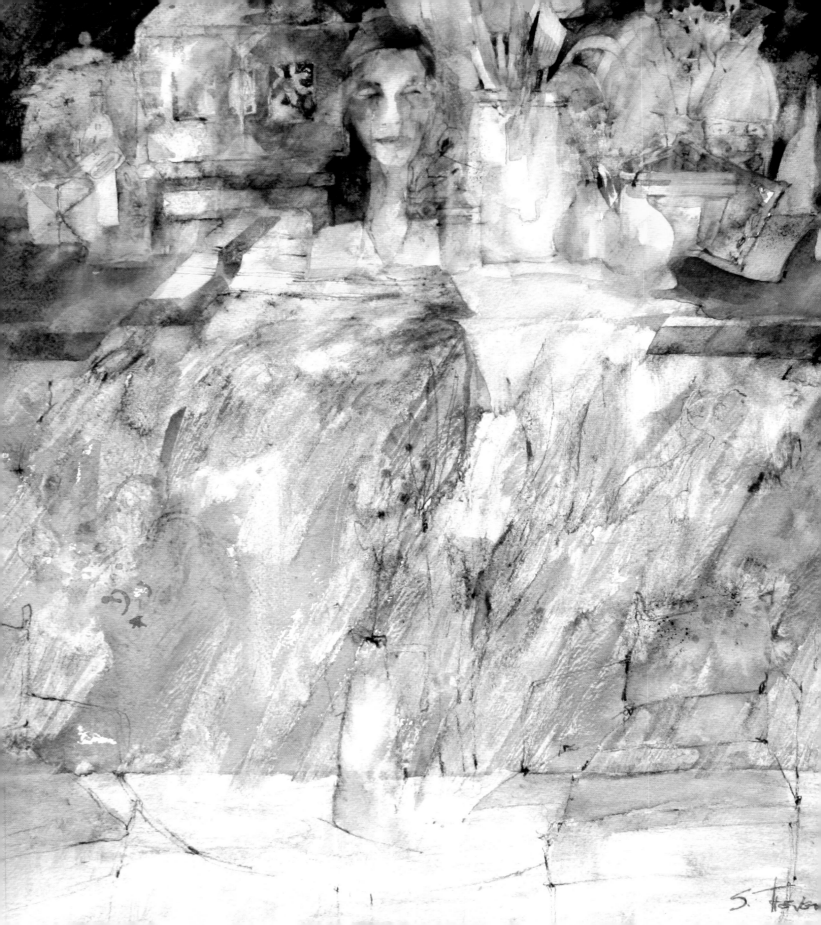

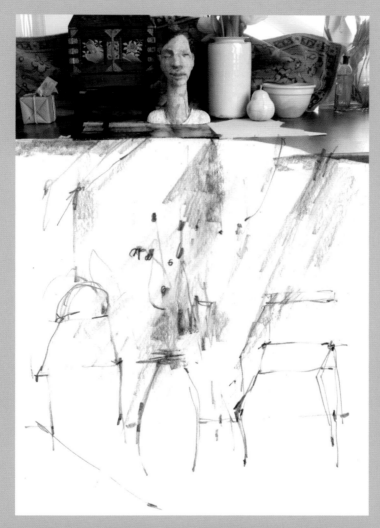

Composition for *Still Life with a Clay Head* (2010)
Photography and pencil. Clay Head by Alain Guy
53 x 46cm (21 x 18in)

*Still Life with
a Clay Head* (2010)
Watercolour and
graphite pencil
53 x 46cm (21 x 18in)

Objects on a studio shelf slowly start to melt into the foreground.
There is just a hint of chairs and a table with a vase of twigs
but they don't tear your eyes away from the beautiful sculpted
head with the long neck and mysterious smile.

Sketch for *Fruit Bowl and Sunflowers* (2010)
Coloured pencil
8 x 8cm (3 x 3in)

Sunshine and the promise of tea in the garden with cups and mugs and a bowl of sugar. Fruit spills out on to the table and, sending a golden glow over the whole table, are sunflowers, big and bold.

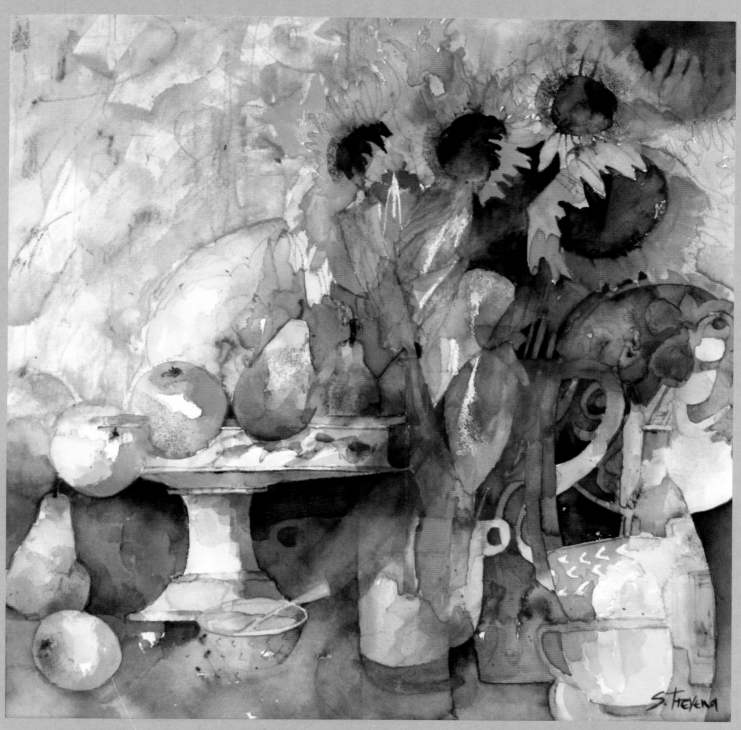

Fruit Bowl and Sunflowers (2010)
Watercolour
48 x 48cm (19 x 19in)

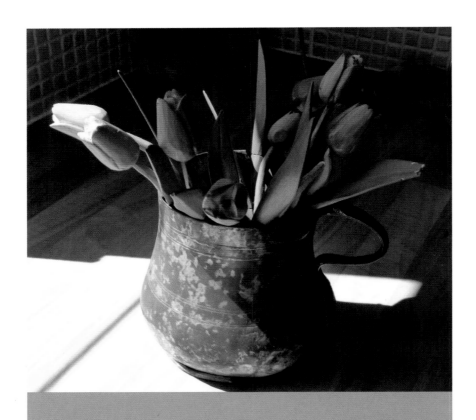

This small copper jug was part of the still life *Fruit and Flowers Against a Blue Curtain.* The little tulips are carved from wood and have been used in several of my paintings.

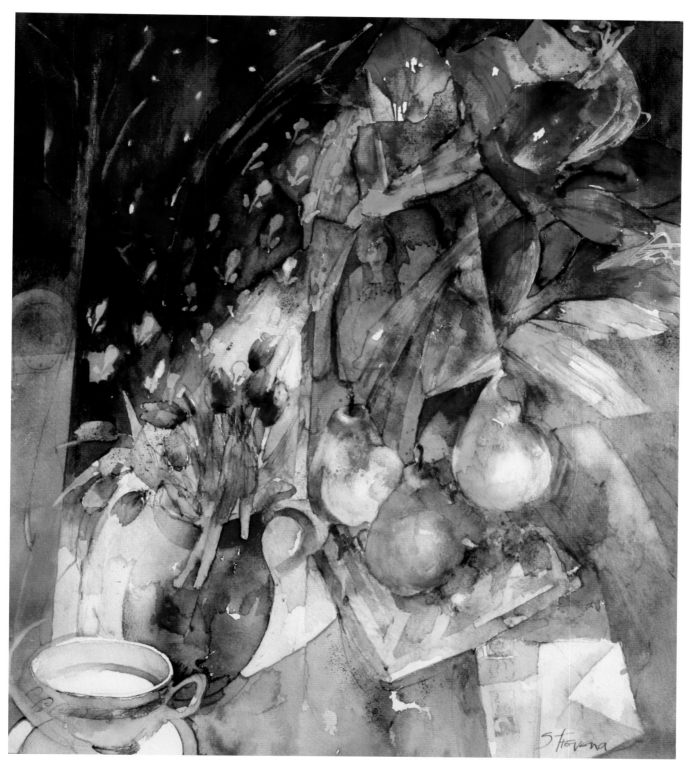

Fruit and Flowers Against a Blue Curtain (2011)
Watercolour
47 x 42cm (18½ x 16½in)

Time doesn't take away
from friendship, nor does
separation.

Tennessee Williams

Flowers from Ann's Garden, detail (2011)
Watercolour
18 x 16cm (7 x 6¼in)

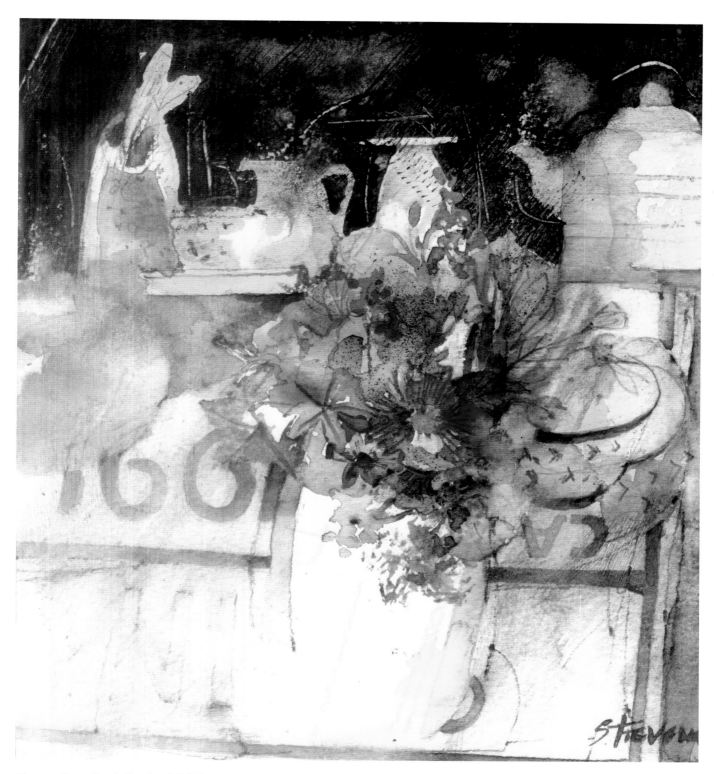

Flowers from Ann's Garden (2011)
Watercolour
18 x 16cm (7 x 6¼in)

Patterns, faces, words.
I put anything I could find in
random magazines to conjure up
a moment in the history of the
Russian church, with the rich
vestments of the priests, solemn
processions with banners and icons.
It's almost a self-portrait and I'm
surrounded by mystery and ritual.

***Russian Collage* (2011)**
Watercolour
32 x 44cm (12½ x 17in)

S. Trevena

Flowers often leave
impressions of colour
indelibly burned
on to my brain.

Henri Matisse

Sunshine on Tulips (2011)
Watercolour
27 x 36cm (10½ x 14in)

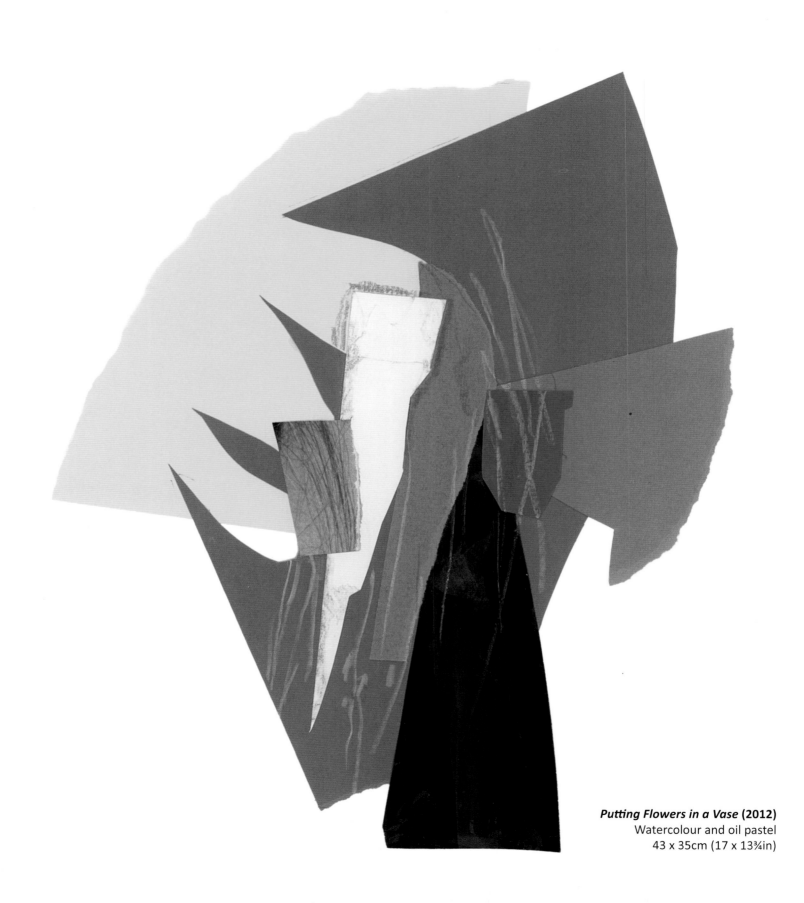

Putting Flowers in a Vase (2012)
Watercolour and oil pastel
43 x 35cm (17 x 13¾in)

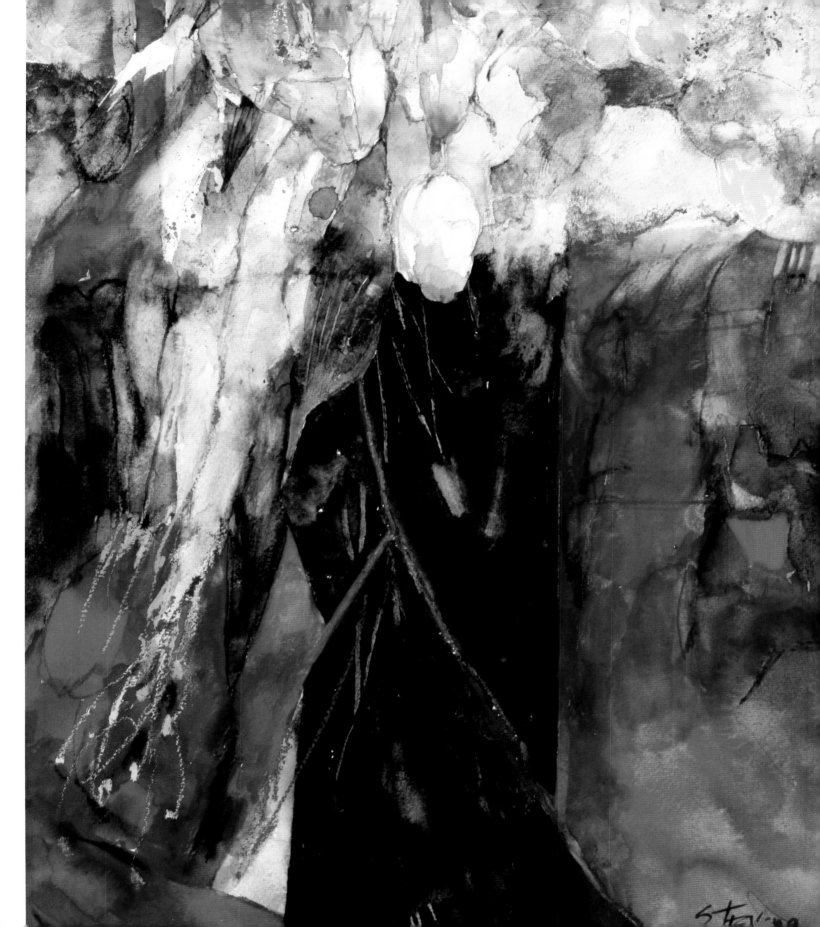

Ready to Dance **(2003)**
Monoprint
29 x 18cm (11½ x 7in)

Dressed to the nines as
my mother would say.

Ready to dance
and ready to strut.

Just 16 years old –
a real 'look at me'.

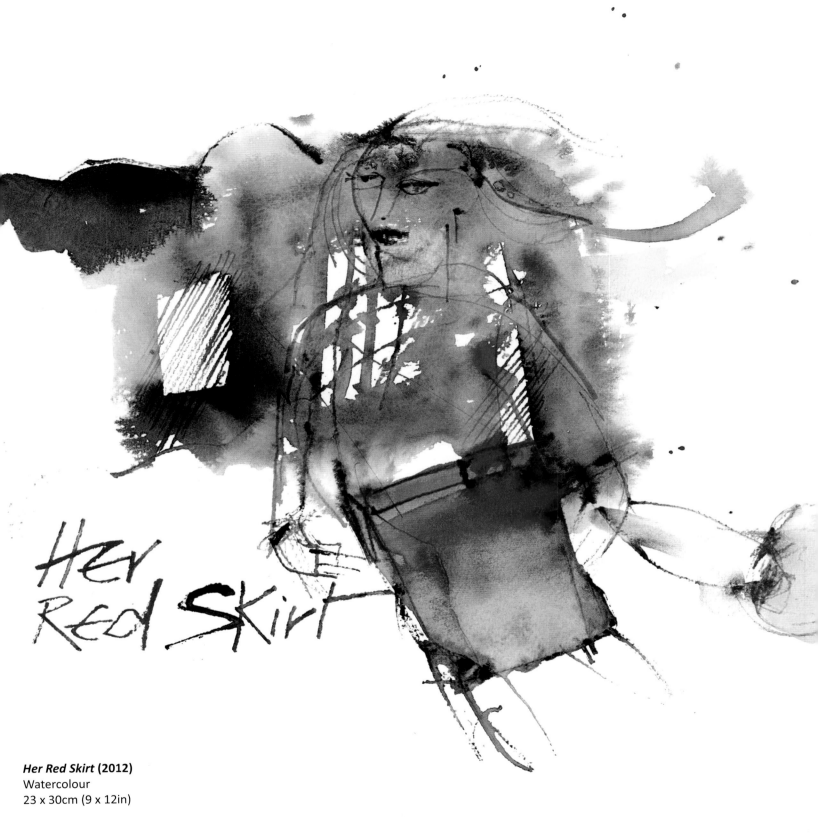

Her Red Skirt **(2012)**
Watercolour
23 x 30cm (9 x 12in)

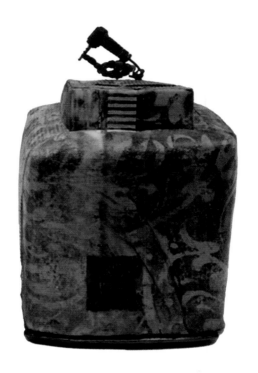

This Robert Cooper tea caddy was my inspiration and starting point for this painting.

Tea Caddy
by Robert Cooper
Ceramic

Plants and Glass Bottles **(2012)**
Watercolour and graphite pencil
52 x 49cm (20½ x 19¼in)

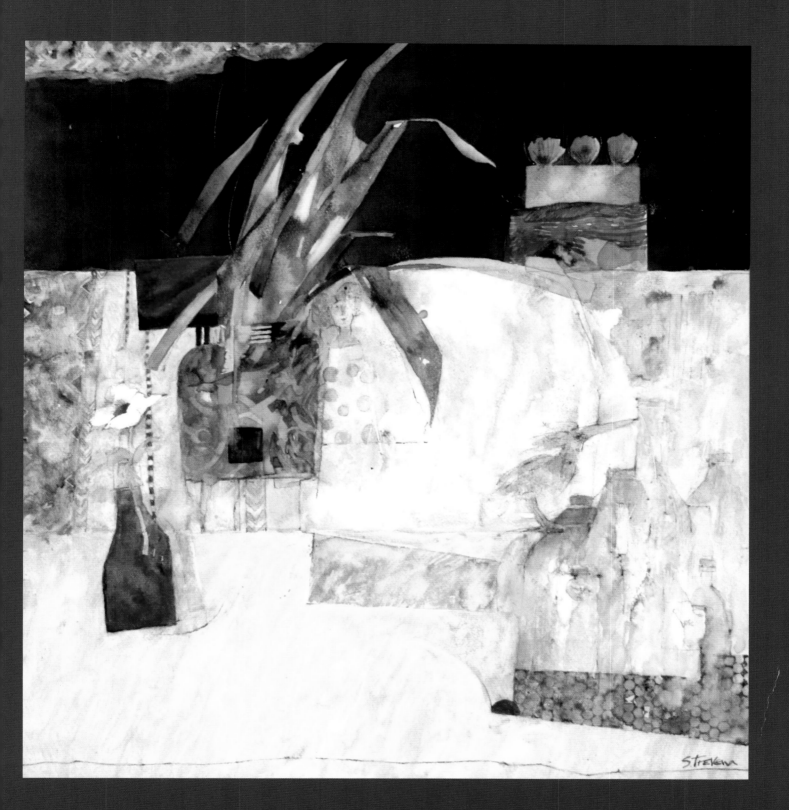

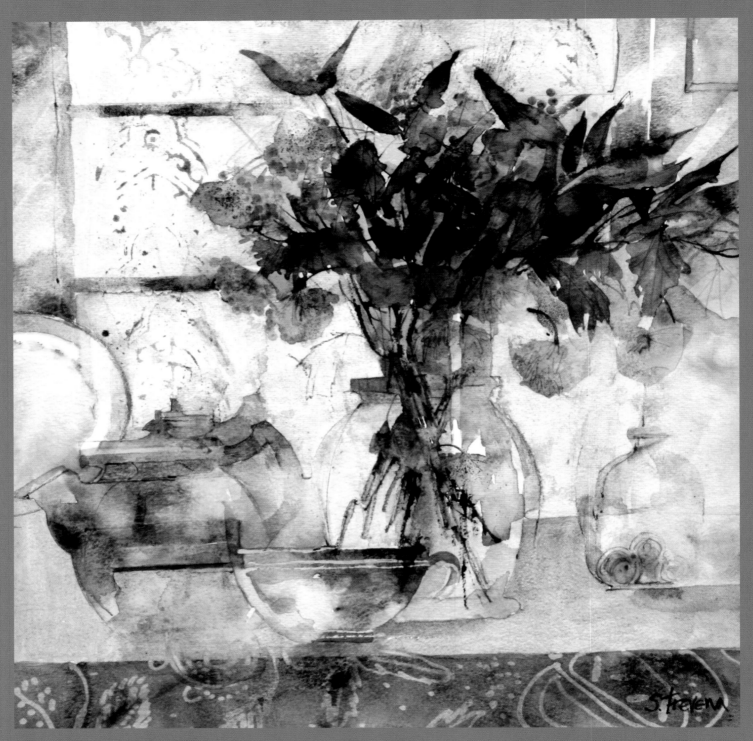

Green Teapot, Green Leaves (2012)
Watercolour
38 x 38cm (15 x 15in)

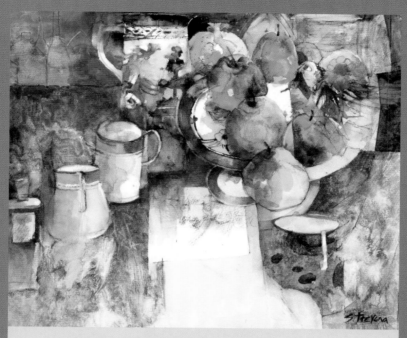

Crunchy Green Apples (2012)
Watercolour
34 x 40cm (13½ x 15¾in)

Green. Not my favourite colour
but put it with blue and, well,
not bad I suppose...

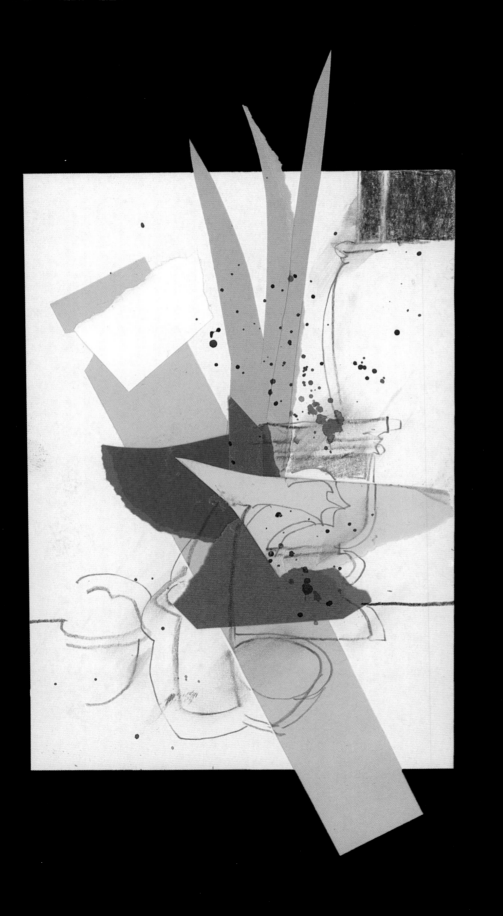

*Blue Still Life with
Black Screens* **(2012)**
Watercolour
38 x 53cm (15 x 21in)

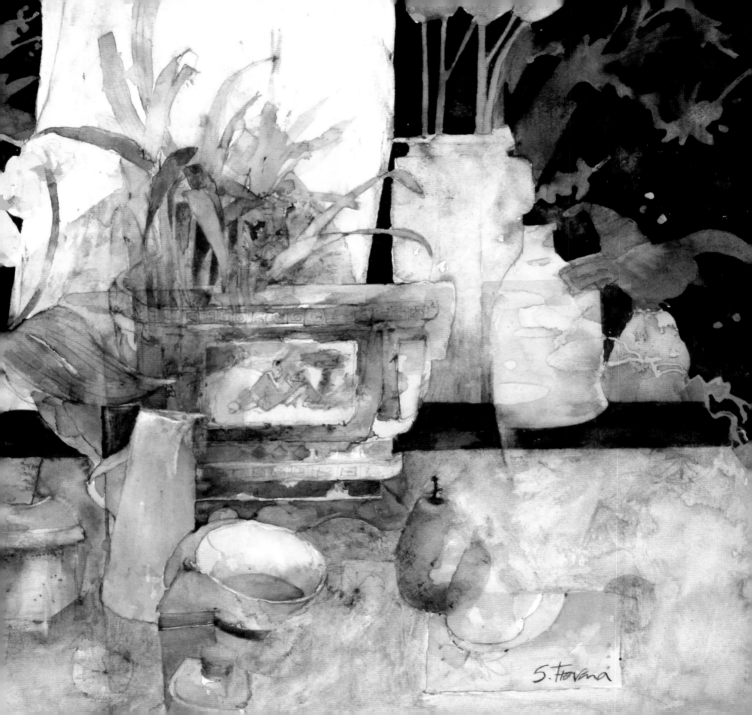

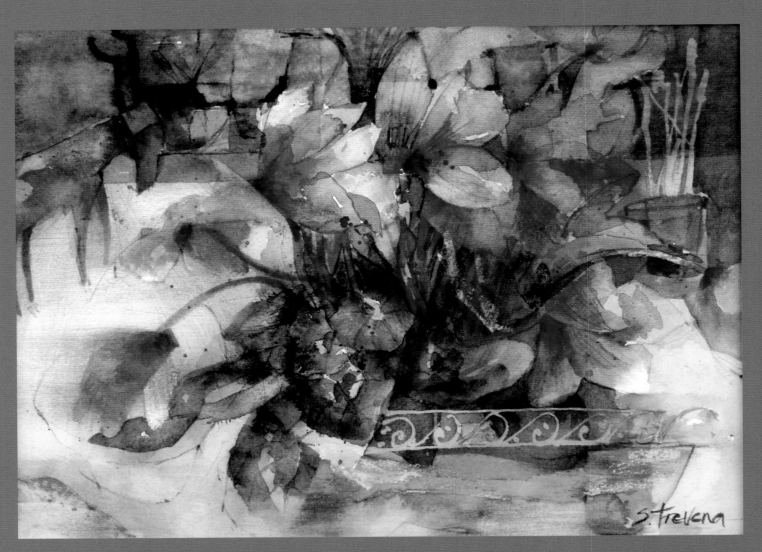

***Cyclamen in a Blue Bowl** (2012)*
Watercolour and oil pastel
24.5 x 33.5cm (9¾ x 13¼in)

Halfway through painting cyclamen in a blue bowl I realized it was getting tight, with too much detail. So out came the scrubbing brush to swipe across sections of the paint. You can see the brush marks in the detail of this picture (shown right).

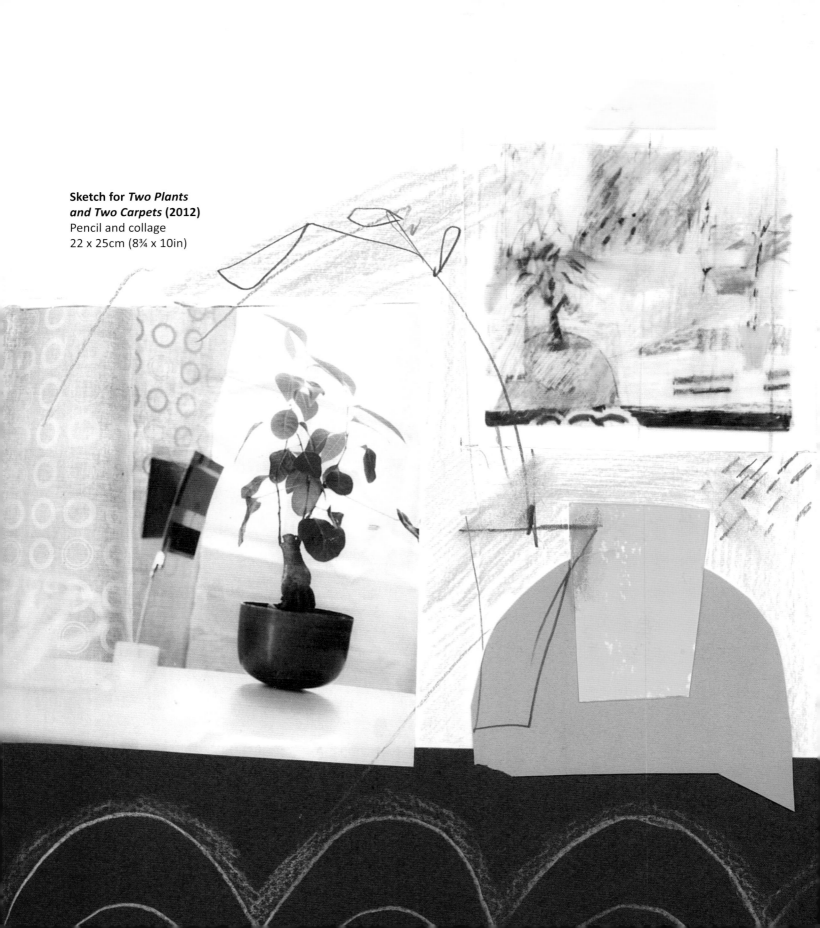

**Sketch for *Two Plants
and Two Carpets* (2012)**
Pencil and collage
22 x 25cm (8¾ x 10in)

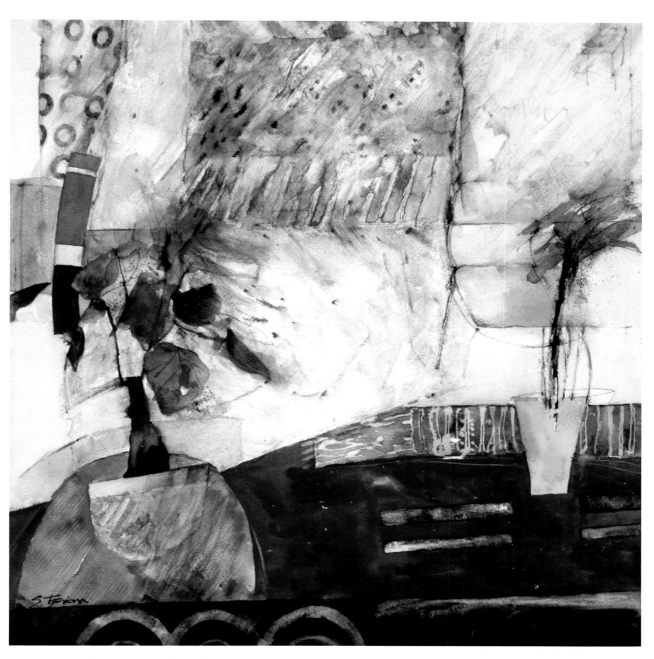

Two Plants and Two Carpets (2012)
Watercolour and graphite pencil
47 x 47cm (18½ x 18½in)

This is one of those paintings that happened quite quickly with very little planning. I have found that occasionally, if I approach a painting with the idea that it is only going to be a sketch, I can relax into it and be more intuitive.

Table Top with Green Leaves (2012)
Watercolour
23 x 33cm (9 x 13in)

The leaves on a stem of lilies are perfect for forming knife-like shapes that cross each other, making triangular negative shapes. In this painting I have changed their natural colour into sharp greens and yellows to bounce off the pink of the petals.

Window Still Life (2012)
Watercolour and graphite pencil
45 x 38cm (17¾ x 15in)

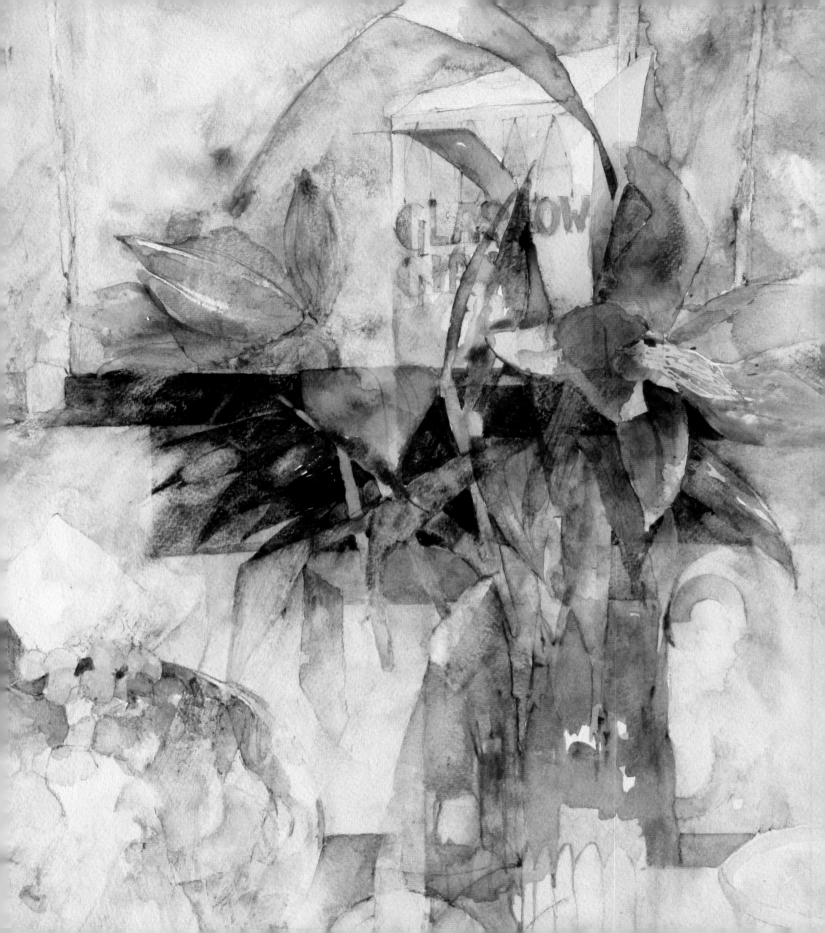

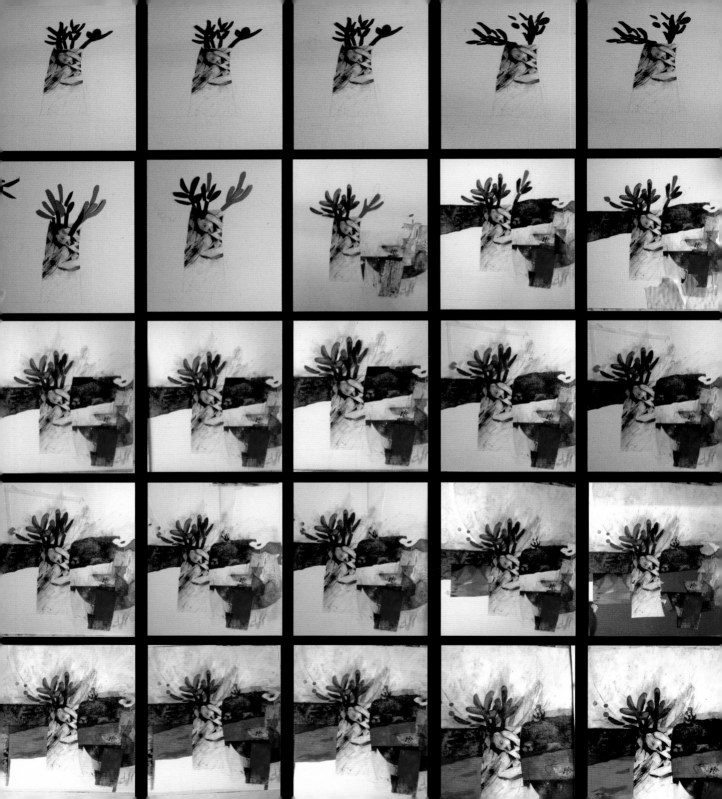

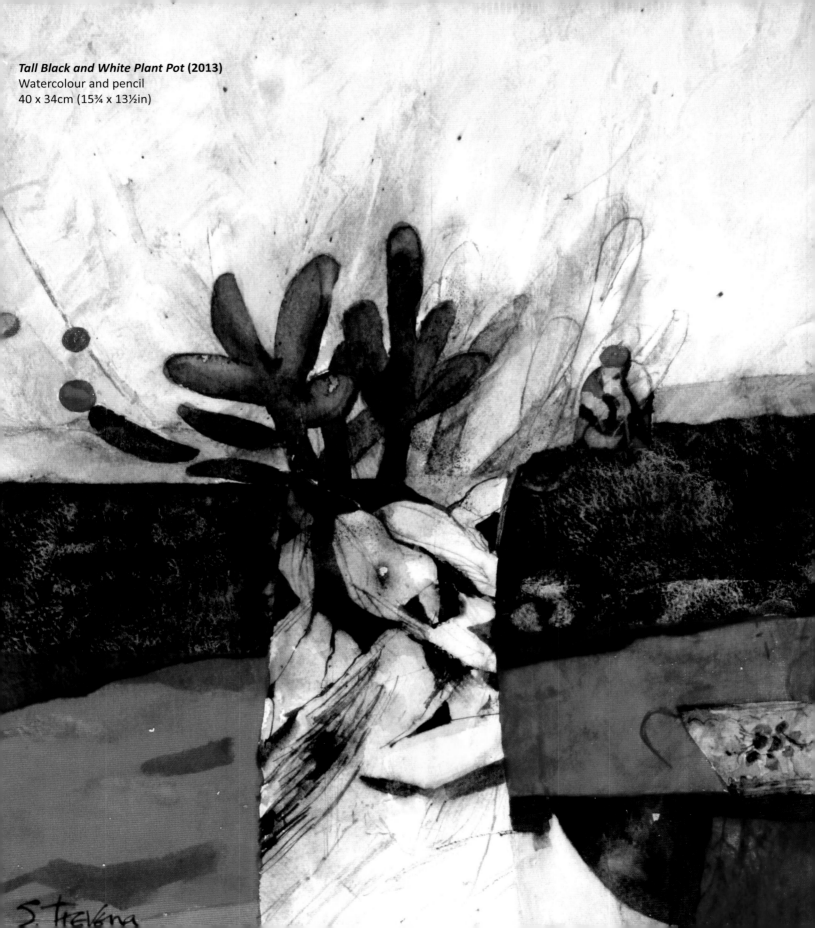

Tall Black and White Plant Pot **(2013)**
Watercolour and pencil
40 x 34cm (15¾ x 13½in)

Peonies are so hard to paint.

**Sketch for *Peonies on a
Black and White Cloth* (2013)**
Coloured pencil
8 x 8cm (3 x 3in)

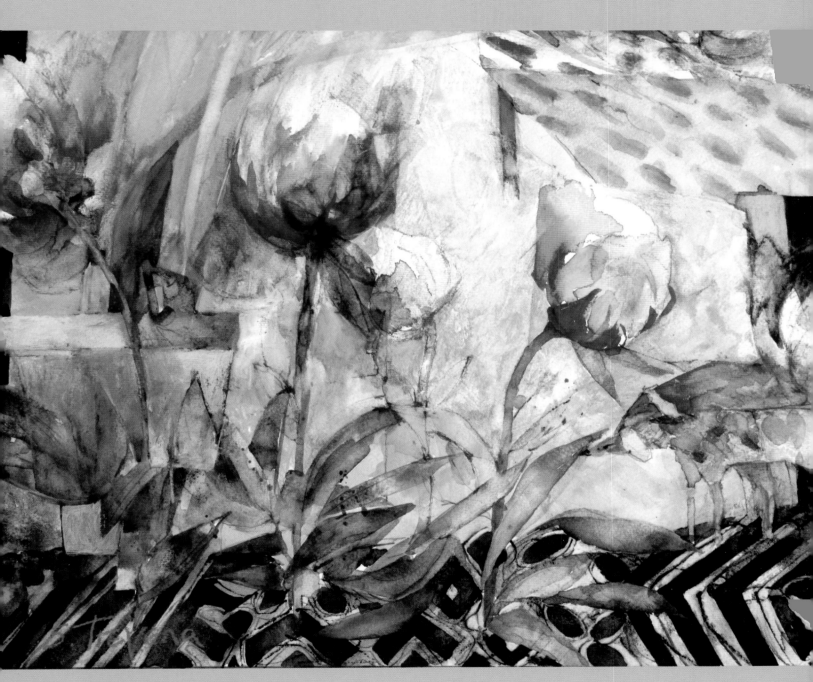

Peonies on a Black and White Cloth (2013)
Watercolour
36 x 47cm (14 x 18½in)

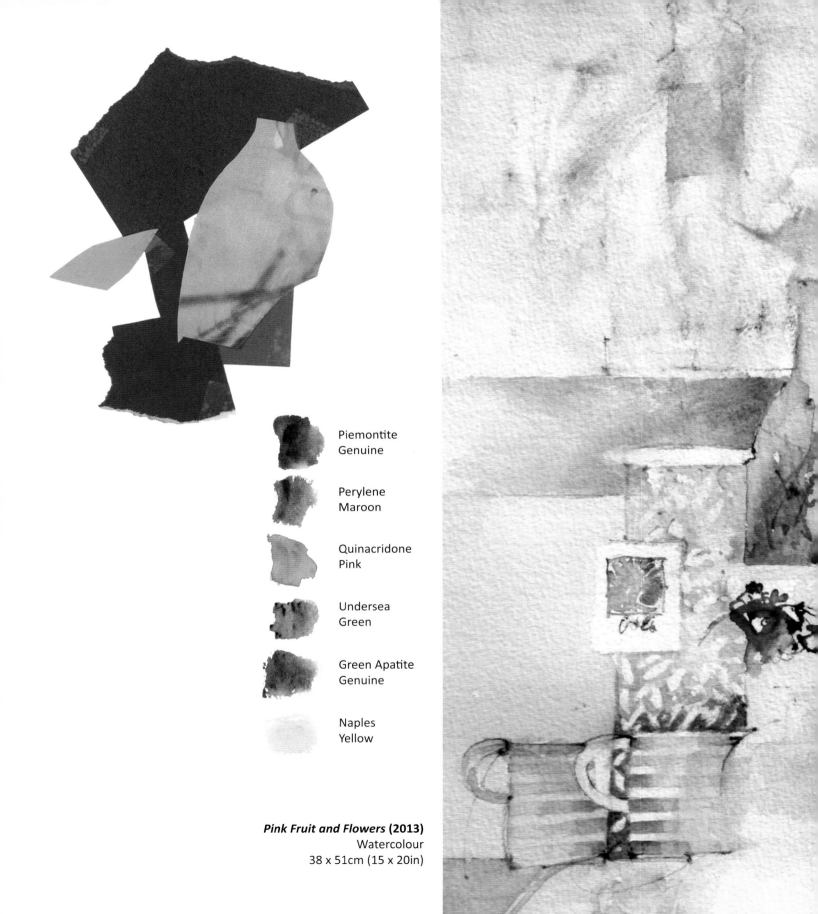

Piemontite
Genuine

Perylene
Maroon

Quinacridone
Pink

Undersea
Green

Green Apatite
Genuine

Naples
Yellow

Pink Fruit and Flowers (2013)
Watercolour
38 x 51cm (15 x 20in)

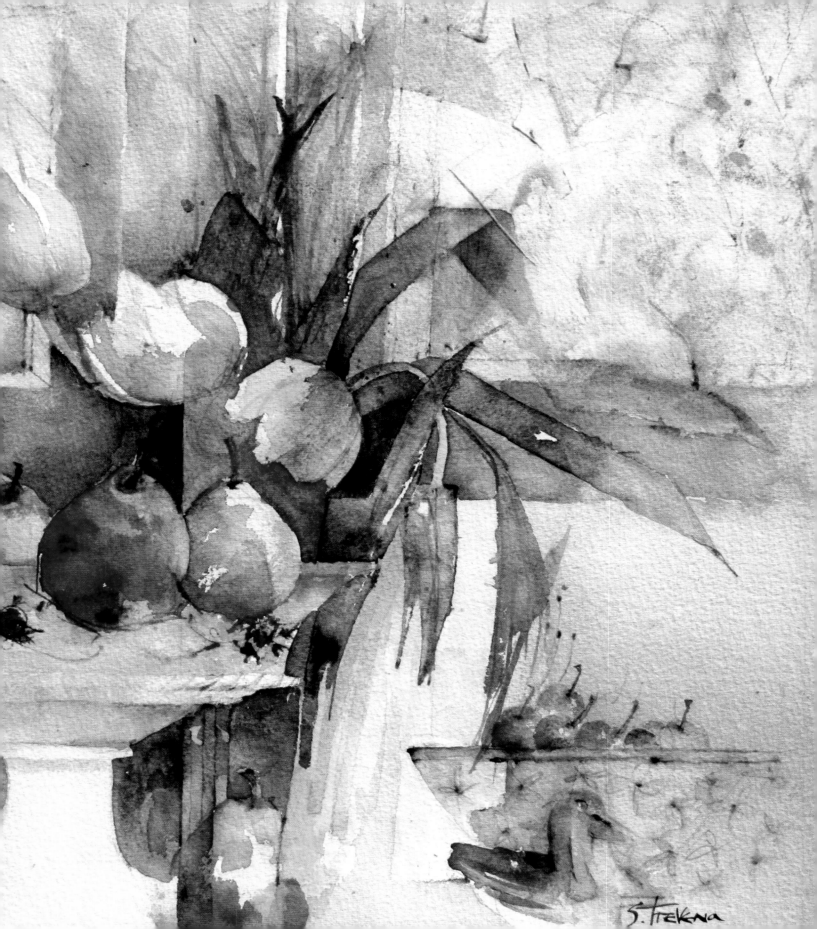

S. Trevena

Amaryllis is the flower that gets my artist's eye very, very interested. These were given to me as a birthday bouquet. The buds were just deep red twists of petals that later developed into teenage flowers, pale pink, long and skinny. Then overnight they became large scarlet trumpets balanced on celery-like stalks. They are the stars of this show and you hardly notice the furniture in the background — the amaryllis demand your attention.

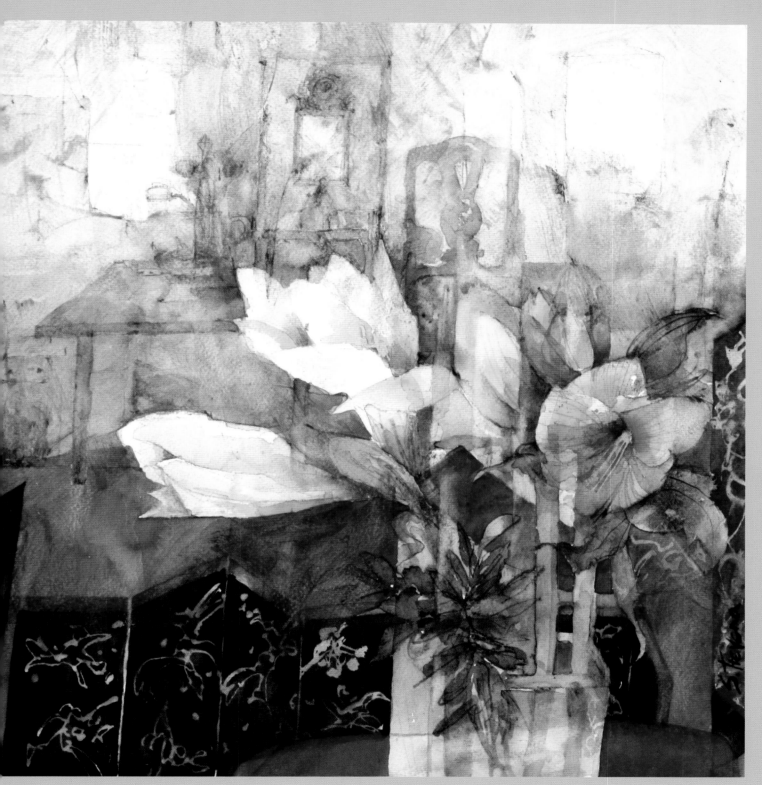

Pink Flowers on a Red Lacquer Table (2013)
Watercolour
42 x 42cm (16½ x 16½in)

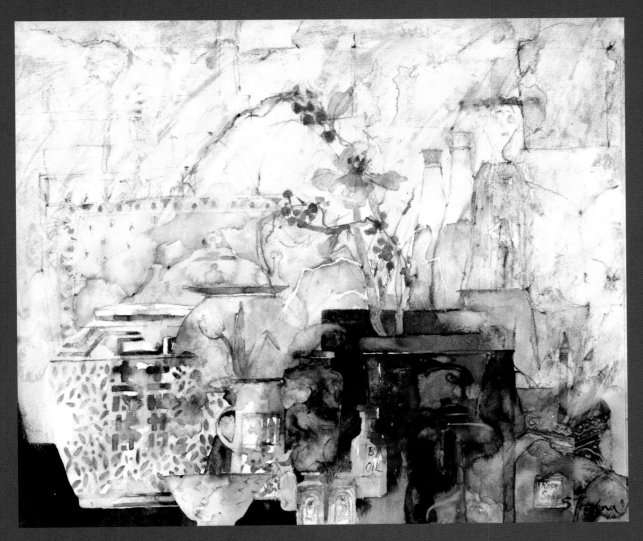

Blues on a Shelf (2013)
Watercolour and graphite pencil
35 x 40cm (13¾ x 15¾in)

Move closer to this painting and the colours become jewel-like ... beautiful
melting blues, greens and reds.

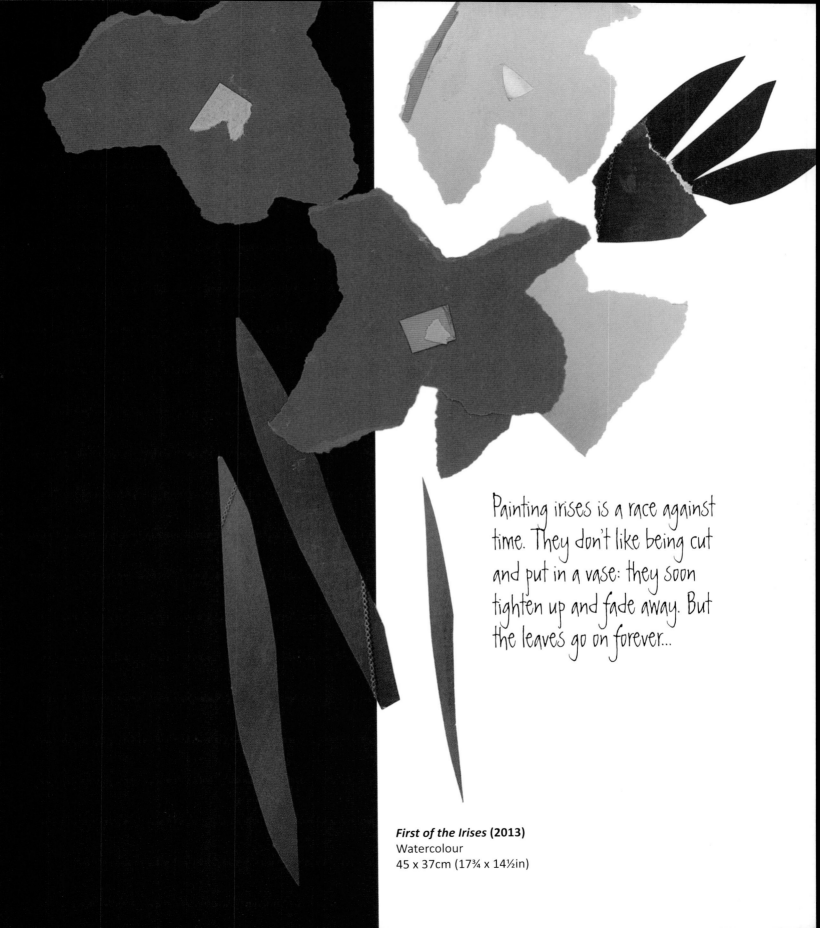

Painting irises is a race against time. They don't like being cut and put in a vase: they soon tighten up and fade away. But the leaves go on forever...

First of the Irises (2013)
Watercolour
45 x 37cm (17¾ x 14½in)

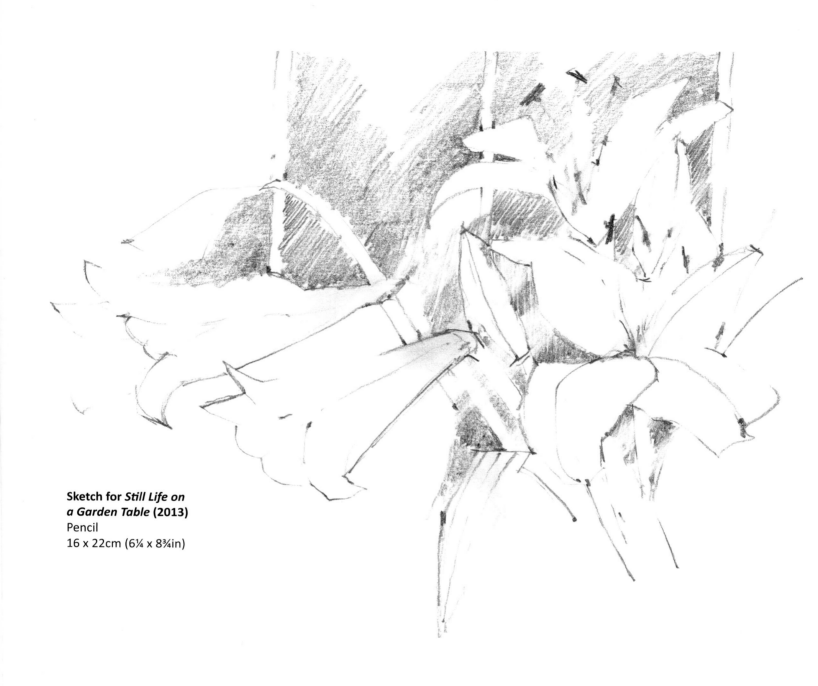

**Sketch for *Still Life on
a Garden Table*** **(2013)**
Pencil
16 x 22cm (6¼ x 8¾in)

Still Life on a Garden Table **(2013)**
Watercolour
45 x 38cm (17¾ x 15in)

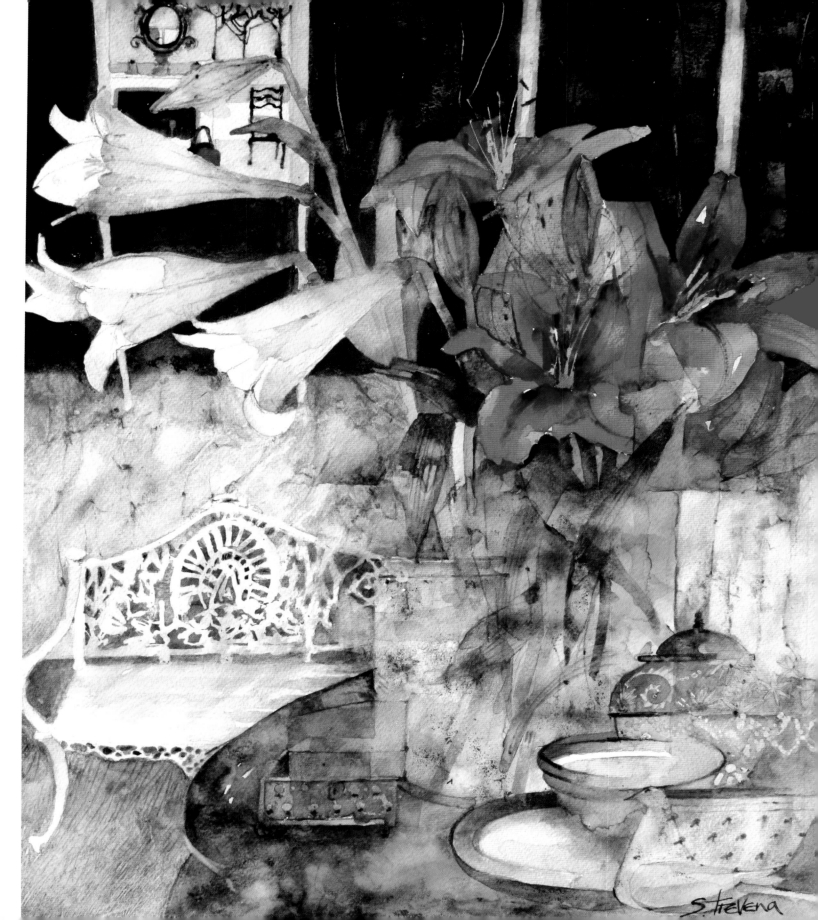

S. Trevena

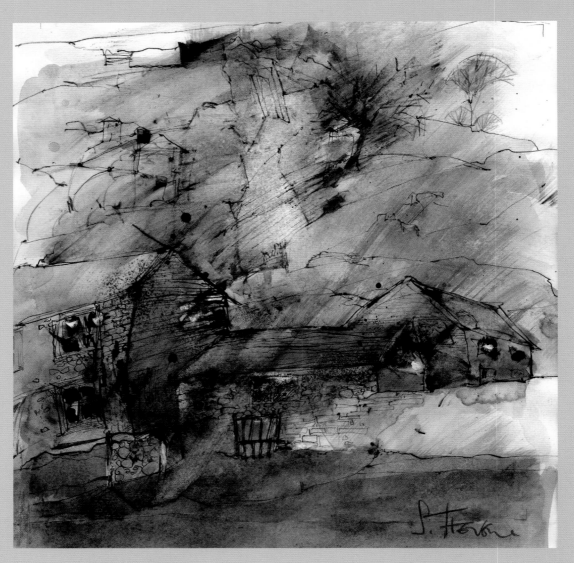

Yorkshire Dales Cottages (2013)
Watercolour, pen and ink
24 x 24cm (9½ x 9½in)

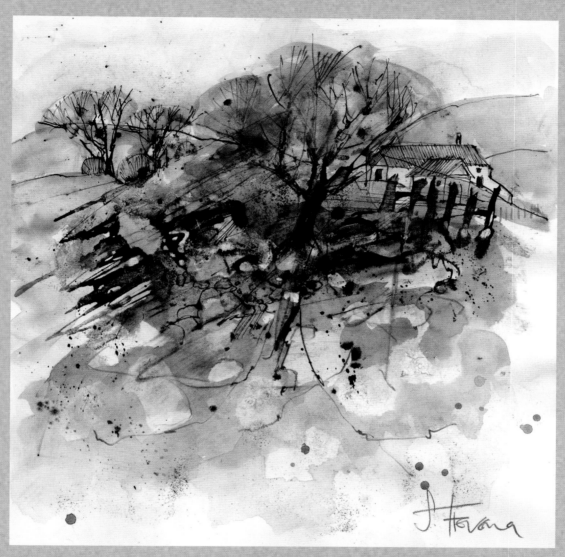

Yorkshire Dales Stony Ground **(2013)**
Watercolour, pen and ink
24 x 24cm (9½ x 9½in)

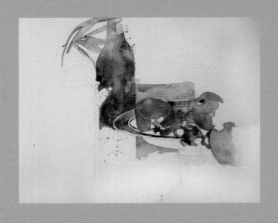
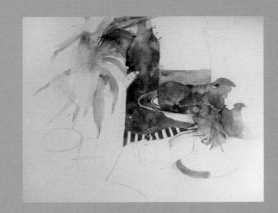
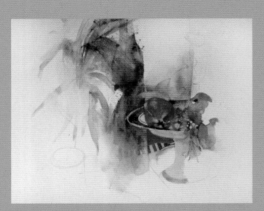
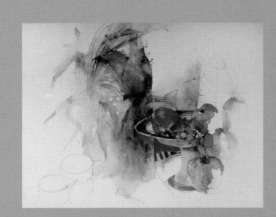
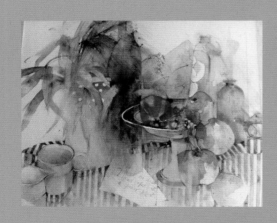
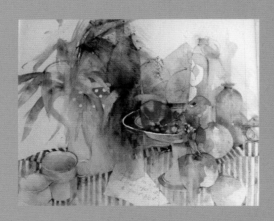

That Red Apple **(2014)**
Watercolour
35 x 32cm (13¾ x 12½in)

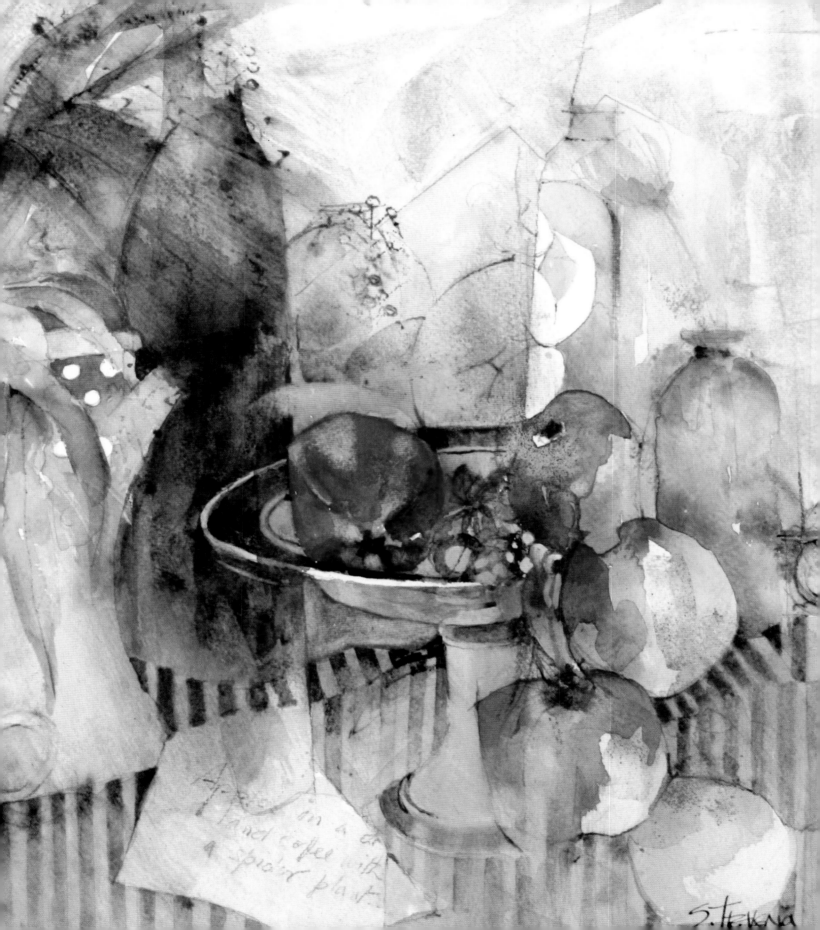

Pears on a red
hand table with
a spider plant

S. Tevena

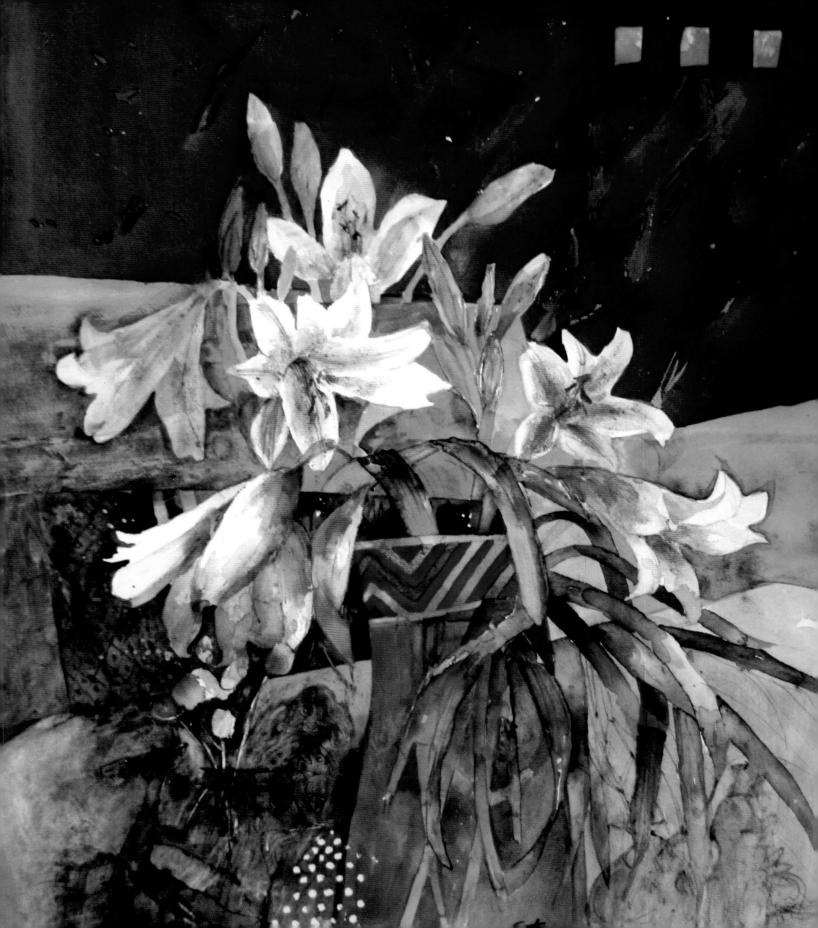

We had moved house and I remember looking out of the kitchen window and seeing a boring concrete wall at the end of the garden. It was very grey. The beautiful shrubs seemed to melt into the wall, their colours drained away. We got used to looking at this view – it's strange how after the first rush of excitement about living in a new home, you settle down and don't even notice things you had planned to change months ago. Then one day I realized that if I could paint a wall in the living room, I could paint one in the garden and so we splashed rich blue paint across the wall and all the flowers and plants suddenly looked vibrant – giving me the idea for this painting.

Against a Blue Wall (2014)
Watercolour
63 x 57cm (24¾ x 22½in)

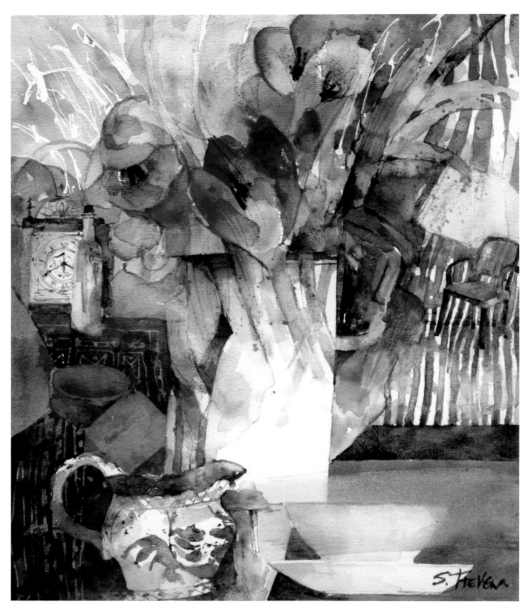

Early spring time, still a little sunshine at
20 minutes to 4 o' clock. It's tea time and my
favourite blue and white milk jug makes an
appearance in the corner of this painting.

April Tea Time (2012)
Watercolour
43 x 36cm (17 x 14in)